VINTAGE SIGNS OF AMERICA

Debra Jane Seltzer

AMBERLEY

This book is dedicated to two people who have inspired and encouraged me immensely. Tod Swormstedt, the founder of the American Sign Museum, has generously answered my questions over the years. Doug Towne, the editor for the Society for Commercial Archeology, has enthusiastically praised my articles and listened patiently to my griping.

First published 2017

Amberley Publishing
The Hill, Stroud
Gloucestershire, GL5 4EP

www.amberley-books.com

Copyright © Debra Jane Seltzer, 2017

The right of Debra Jane Seltzer to be identified
as the Author of this work has been asserted in
accordance with the Copyrights, Designs and
Patents Act 1988.

ISBN 978 1 4456 6948 9 (print)
ISBN 978 1 4456 6949 6 (ebook)

British Library Cataloguing in Publication Data.
A catalogue record for this book is available from
the British Library.

Typeset in 10pt on 13pt Celeste.
Typesetting by Amberley Publishing.
Printed in the UK.

Contents

Introduction

Vintage signs delight us with their designs and connections to the past. They evoke personal memories. They bear witness to a time when nearly all businesses were mom-and-pop stores. The signs at these places were unique works of art and craftsmanship. From the 1920s until the 1970s, American streets by night were magical wonderlands of light, colour, and movement. Today, most downtowns have been stripped of these signs. However, even in the smallest of towns there are usually a few old signs that still cling to their projecting poles despite the modernisation and changes of tenants beneath them.

At the time of writing this book, all the signs presented were still on public display. However, any of them could vanish at any time. Most of the signs shown here are from the 1940s and 1950s, which is considered the golden age of neon. You will also find examples of increasingly rare opal glass letter signs and bulb signs from the 1920s and 1930s. Also included are stylish and under-appreciated plastic signs from the 1960s and 1970s. Many of these signs are well maintained and lit at night. Others haven't been painted or repaired in decades. It is my hope that through sharing some of the histories of these signs that you will come to appreciate them even more and be inspired to do what you can to save them.

This book is organized into three sections:

Types of Signs: different materials used, display methods, and special features.
Themes: a sampling of 'figural signs' with representations of people, animals, and things.
The Future of Vintage Signs: preservation issues and approaches to saving signs.

In 2001, I began documenting and researching buildings, signs, and statues for my website www.RoadsideArchitecture.com. Since then, I have logged more than 450,000 miles maniacally gathering photos from forty-eight states. At this point, my website has over 2,500 pages and more than 60,000 photos. Between my website and blog, I have photographed well over 10,000 vintage signs. The photos in this book were all taken by me.

Since 2007, I have been writing about signs for the Society for Commercial Archeology's publications. My passion for old gas stations, mid-century modern buildings, fiberglass statues, and the like is exceeded by only one thing: my dogs. My active and amusing little terriers accompany me on all my road trips. They love traveling as much as I do. I have lived half my life in Southern California and the other half in New York City. I love big cities as much as tiny towns.

Types of Signs

Bulb Signs

The earliest illuminated signs were lit with incandescent bulbs. Between 1900 and 1910, tens of thousands of these signs were installed all over the country. With the development of neon tubing in the 1920s, most businesses replaced their bulb signs with neon signs. Most signs produced from the 1930s onward have used incandescent bulbs primarily as a secondary, flashing accent. One popular early bulb sign design was in use by 1910. It was created by Federal Electric and consisted of a navy blue panel surrounded by a stylish, steel frame. Twelve bulbs spaced around the frame illuminated the panel at night.

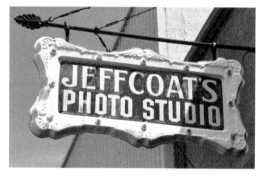

In 1925, one of these signs was installed at the Jeffcoat's Photography Studio in Abilene, Kansas. Since 2008, the space has housed the Jeffcoat Photography Studio Museum. After more than ninety years, the sign's navy blue panel has faded a bit and the bulbs are no longer lit. However, this may be the only example of these framed signs still at its original location.

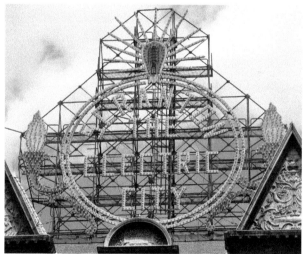

The Electric City sign in Scranton, Pennsylvania is installed on the roof of the Scranton Electric Building. The sign was built in 1916 and is 60 feet tall. It is composed of 3,500 bulbs with 1,300 flashing bulbs. The sign was dark from 1972 until it was restored in 2004. The restoration took two years and cost about $180,000. In 2014, the sign was restored again. This time, the incandescent bulbs were replaced with LED bulbs in the original colours of red, green, white and amber. The torches' flames flicker and the circles' bulbs flash to appear to rotate in different directions. The giant light bulb at the top of the sign has sequentially lit rays.

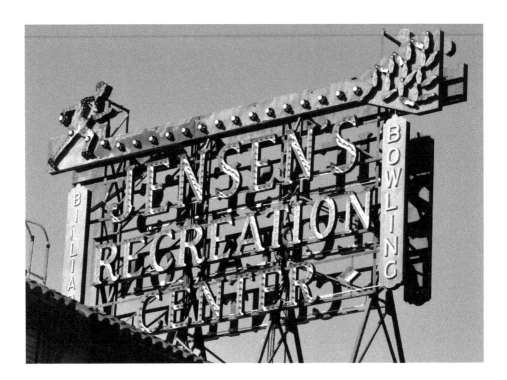

The Jensen's Recreation Center sign in Los Angeles was built in 1924. This rooftop sign was erected then or shortly thereafter. It is 28 feet long and 17 feet tall. There are an estimated 1,300 red, green, and white bulbs. The building originally had a bowling alley and pool hall. The man at the top of the sign bowls a strike with bulbs lit in sequence into exploding pins. The letters in the centre of the sign are also lit sequentially. The vertical panels on the sides of the sign have backlit opal glass letters. The sign was restored and relit in 1997. The building was sold in 2014 and the new owner plans to restore the sign again.

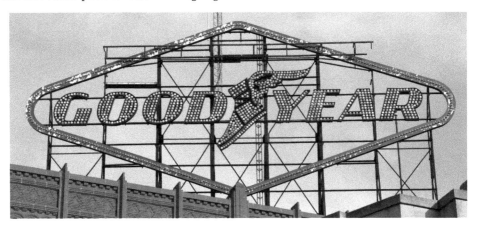

This Goodyear sign is located in Akron, Ohio at the company's former headquarters. Two neon rooftop signs preceded this one, which was installed sometime after 1954. The Goodyear letters and 'Wingfoot' are composed of about 700 yellow bulbs. From 1963 until at least the late 1990s, the sign flashed 'Go, Go, Goodyear.' Goodyear moved to a new location in 2013. In 2015, the conversion of the building into retail and residential use began. There are plans to eventually relight the sign with LED bulbs.

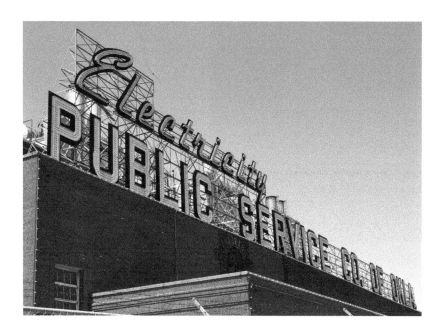

The Public Service Co. of Oklahoma sign in Tulsa was built in 1955 on top of the company's power station. At that time, it was the largest electric sign in Oklahoma. The PSO sign is 336 feet long and 40 feet tall. The letters are lit with 3,249 bulbs. The incandescent bulbs were replaced with LED bulbs in 2012. The sign has never flashed.

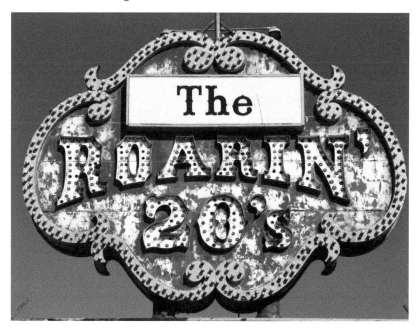

The Roarin' 20s sign in Grants, New Mexico was originally located at Eddie McBride's nightclub in Albuquerque. The sign is believed to be from the 1950s. When the business closed sometime after 1971, Eddie moved the sign to his father's place, the Sunshine Cafe, Bar, and Dance Hall. The 'Eddie's' on the sign was covered up with a plastic panel. The Grants Main Street project is interested in restoring the sign. However, the owner wants $50,000 for the sign.

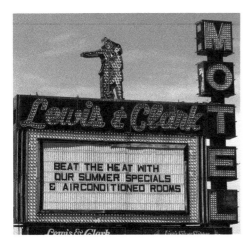

The Lewis & Clark Motel sign in Bozeman, Montana was built in 1975. It was designed and built by William J. Sebena, the owner of the motel. He had no sign experience but was assisted by a friend that did. Sebena was inspired by signs in Las Vegas. There are 2,300 incandescent bulbs on each side of the sign. Sebena's daughter now runs the motel and wants to keep the sign as original as possible. She does not plan to update it with LED. The bulbs are broken frequently during hailstorms. The readerboard in the centre of the sign revolved originally. The sign's letters are outlined with neon and are lit sequentially.

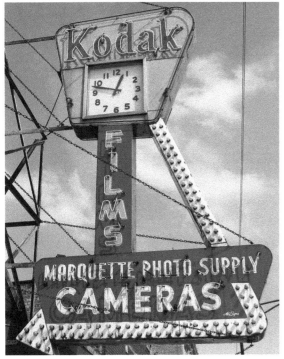

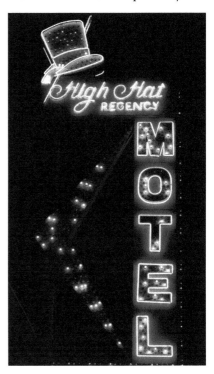

Above left: Marquette Photo Supply in Chicago, Illinois was established in 1947. The sign was built in the late 1950s by the Ad Deluxe Sign Co. Unlike production signs with brand names, this sign was unique. Permission had to be obtained from Kodak before it was built. The sign is not currently operating. When it was lit, it featured pink and gold neon. The clock was backlit and the arrow had chasing bulbs. This sign hangs over the sidewalk. It was secured to the building with an elaborate steel structure mounted on the roof. There are still hundreds of these supports in Chicago, most of which are missing their signs.

Above right: The High Hat Regency Motel sign is located in Las Vegas, Nevada. The sign previously advertised for the Chevron Motel. At that time, it was a simple sign with just backlit plastic panels. In the 1960s, it had an arch on top with a suspended bulb-studded ball. That was removed when the name was changed to the High Hat. The flashing bulbs and neon were added at that time.

In the early 1900s, Federal Electric and other sign companies began producing sign panels with bulbs installed directly over the letters. In 1903, Federal Electric developed and patented its modular letter signs. The company called them 'sectional lamp letter signs.' The signs were composed of mass-produced, individual 16-inch-tall letter panels. The panels were made of porcelain enameled steel, which was a vast improvement over other metal signs that were prone to rust and required repainting every few years. These 'off the shelf' letters could spell out the business name or more generic text. This concept made sign construction faster and less costly. When businesses closed, these letters could be removed by the sign shop and recycled to create another sign. The letters could also be animated with a flashing mechanism if the customer desired it. The customer also had a choice of different border designs. By the 1920s, Federal Electric had produced thousands of these sectional signs. Today, there are only about a dozen of them still hanging.

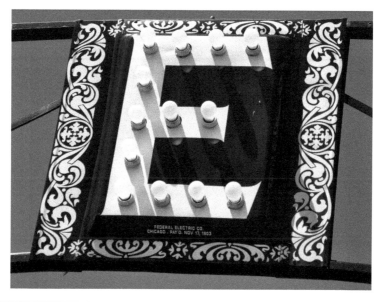

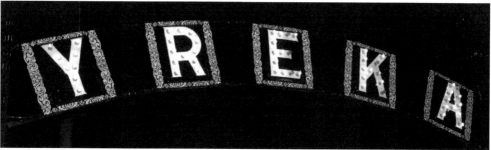

The Yreka Arch sign in Yreka, California was built in 1917. It originally spanned a street downtown. The sign was removed in the 1930s and put in storage. It was restored in 1977 and installed in its current location in a traffic circle. Each letter bears the original manufacturer's markings at the bottom – 'Federal Electric Co. Chicago. Pat'd. Nov 17, 1903.'

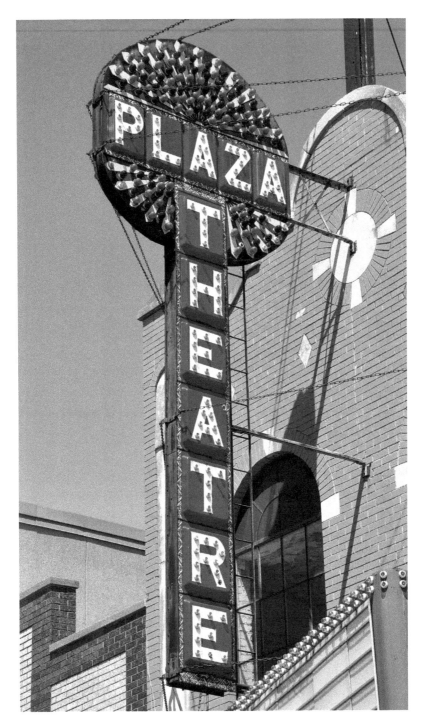

The Plaza Theatre in Glasgow, Kentucky opened in 1934 and this sign was installed then. What makes this sign unusual for a Federal Electric sectional sign are the red panels. There are no other examples of this and it's not known if others were produced. The bulbs used for the letters are static, but the starburst's bulbs are lit sequentially from the inside to the outside of the sign. Those bulbs have red and yellow covers, which add colour to the sign at night.

Opal glass signs were built from the 1910s through the 1930s. The letters were made of translucent glass and backlit with light bulbs inside the sign. Many people refer to these letters as 'milk glass', since most of them were white. However, other colours were produced as well. The letters came in a variety of sizes and typefaces. Each letter was produced on a separate plate and installed inside the sign. The metal panels were perforated to allow the raised letter shapes to protrude. These letters had two advantages over painted signs. The wording could be read at an angle by pedestrians and motorists. In addition, the brightness of the letters increased the sign's visibility. These signs were produced by many sign companies for businesses of all kinds and sizes. Department stores and theatres used the letters on message boards. By the mid-1930s, production of opal glass signs had all but ceased due to the popularity of neon. Over time, opal glass letter signs were either scrapped and replaced or adapted with neon borders or neon tubing installed directly over the sign's letters. Only a few dozen opal glass signs remain on display.

One nice example is located in Santa Maria, California, where it hangs on the side of the building that housed the W.A. Haslam Company, a men's clothing and dry goods store. In 1906, Haslam moved into the Independent Order of Odd Fellows Building. The sign was installed around 1920. The sign is an example of a Federal Electric sectional sign produced with opal glass letters rather than bulbs. It is about 12 feet tall.

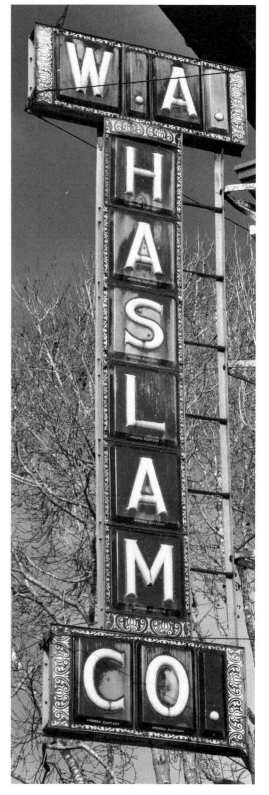

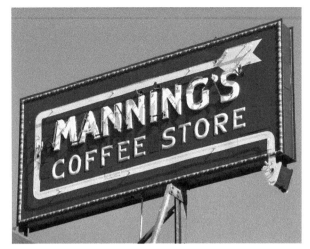

The Manning's Coffee Store sign in Los Angeles, California was built in 1933. The coffee shop was part of a West Coast chain. The raised 'MANNING'S' letters and arrow are accented with neon. The 'COFFEE STORE' letters are composed of opal glass letters. Tin border details like those on this sign were common on signs in the 1920s and 1930s. This sign was originally installed in Hollywood. It was moved to its present location in 1936. The coffee shop closed in the 1950s. In 2012, the sign was restored with funding from the National Trust Service Route 66 Corridor Preservation Program.

The Wineman Hotel in San Luis Obispo, California was built in 1930. This sign was installed then. It was removed in 1999 when it became dangerously close to falling off the building. During a 2009 restoration of the hotel, the sign was found at a junkyard. It was restored and reinstalled. It is the only animated sign in town. The 'HOTEL' letters are separately soldered onto the sign with neon applied on top of each one. This was a common technique used in neon signs built in the 1920s and 1930s. The word 'WINEMAN' is made with opal glass letters.

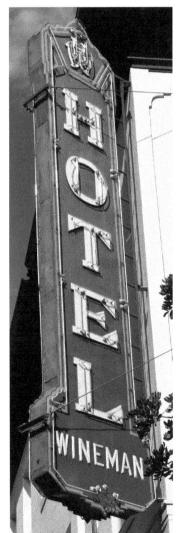

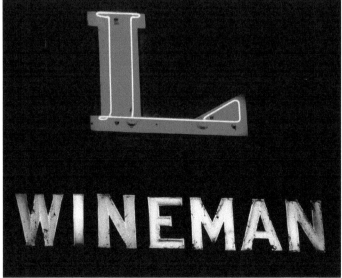

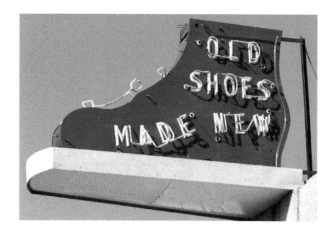

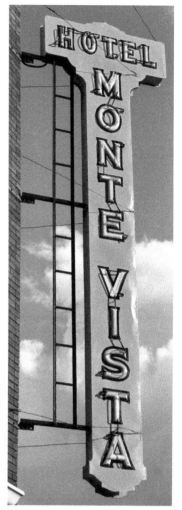

Above: The Montgomery Shoe Factory opal glass letter sign in Montgomery, Alabama was updated at least once with neon. There are two types of housings for the tubing. It appears that the neon border and arrows over the boot's laces were either part of the original sign construction or were later additions. At some point, the neon was applied over the sign's glass letters. This is the only opal glass sign known to still exist that was built in the shape of something.

Right: The Hotel Monte Vista in Flagstaff, Arizona was built in 1926 and this sign is most likely from then. This sign also features ripple tin panels, which were commonly used for signs of this era. The material was lighter than steel and strengthened by the grooved treatment. The ripples also held paint longer than a smooth surface. It is not known when the neon was installed over the glass letters of the Monte Vista sign. The letters are no longer backlit but the red neon is well maintained. The hotel also two other noteworthy neon signs: a scaffold sign on the roof and an entrance canopy sign.

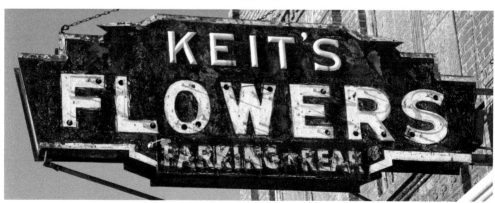

Keit's Flowers in Bay City, Michigan was established in 1856. The flower shop moved to this location in the early 1930s and this sign was most likely installed then. This sign also has ripple tin panels. The top line of text is composed of opal glass letters, while the rest of the letters had neon tubing. Signs in the 1930s frequently had both neon and opal glass.

These vintage signs feature motorized panels and are known as mechanical signs. They caught the attention of motorists and pedestrians with physical movement rather than animated neon. These signs are very rare now. Only a handful of them are still operating.

In the late 1940s, the National Animated Sign Co. of Hot Springs, Arkansas developed a popular 'waver' sign. These signs were about seven feet tall and featured men and women with waving arms. A light bulb was installed behind the waving arm's hand to indicate when a motel had vacancies or a business was open. The company produced many variations including doormen, chefs, gas station attendants, cowboys, Indians, black butlers, waitresses, and clowns. Only a few of them are still on public display. The chef sign here is located at the Isaack Restaurant in Junction, Texas, which opened in 1950. The pole sign and the waving chef were installed a few years later. The chef's arm and the light behind his hand haven't operated since the mid-1960s.

Above right: The Skookum sign in Wenatchee, Washington is about 30 feet tall. The Indian Brave mascot advertised for the Skookum Packers' Association, a local organisation of apple growers and distributors. In 1921, a sign featuring the Indian mascot was installed on steel scaffolding on the roof of the Wenatchee Hotel. When the hotel closed in the 1940s, the Indian sign was moved to the roof of the Skookum warehouse. By 1999, Skookum was long gone and the building was adapted for an Office Depot. During the remodeling, the sign was removed and put in storage. After much public outcry to bring the sign back, the sign was restored and reinstalled in 2000. The sign's two panels are displayed in a triangulated manner with the tips of the feathers touching. The Indian's eyes move back and forth in rapid succession. One of the eyes on each side winked as a window shade like panel moved up and down. By the mid-2000s, the winking panel had stopped working.

 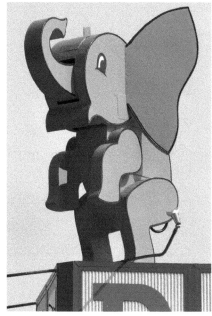

Above left: This sign at the Mule Trading Post in Rolla, Missouri was built in 1981 for a Hillbilly Store. It was based on a smaller sign built around 1943 for another location. The sign in Rolla is 28 feet tall. The Hillbilly Store closed in 2000. The sign has been displayed at the Mule Trading Post since 2007. The hillbilly's motorized arms move in a backstroke motion.

Above right: DT's Package Liquor & Sports Bar in Cheyenne, Wyoming was established in 1937. It is believed that this pink elephant sign was installed in 1955 when a new building was constructed on the site. The elephant is about six feet tall and its motorized head moves up and down.

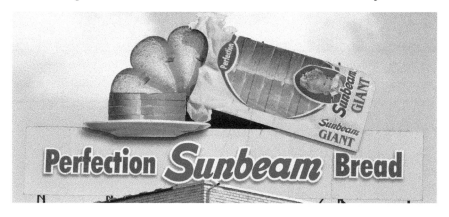

This Sunbeam Bread sign in Fort Wayne, Indiana was built in 1957. The 36-foot-long 'Endless Bread' sign was installed on the roof of the Perfection Biscuit Company bakery, which produced Sunbeam bread. The sign features a wheel with nine slices of bread that spin to create the illusion of sliced bread piling up on a plate. In 2007, the sign was restored with new aluminium and plastic panels. Instead of using paint, the sign company used vinyl film, which holds up better to sun and weather. The digital printing on the sign made it possible to give the bread texture. The bag, plate, and letters are now more three-dimensional in appearance. The sign is illuminated at night with spotlights just as it was originally.

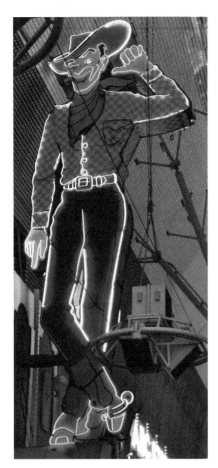
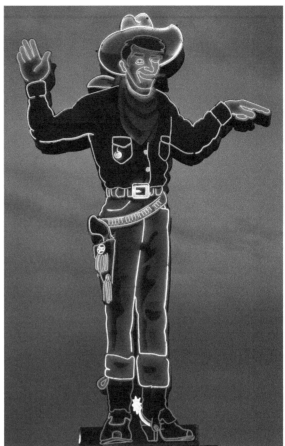

Above left: The Vegas Vic sign was designed for the Pioneer Club in Las Vegas, Nevada by Patrick Denner from YESCO in Salt Lake City. The 40-foot-tall sign was installed in 1951. At the time, it was one of the most expensive signs in Las Vegas. Vegas Vic had moving arms and an animated neon cigarette that blew smoke rings. Vic's arms stopped moving in 1991. In the mid-1990s, Vic's cowboy hat was shortened by a few feet to fit the sign under the Fremont Street Experience canopy.

Above right: The Wendover Will sign in Wendover, Nevada was modelled after Vegas Vic and built in 1952. With permission from the Pioneer Club in Las Vegas, this nearly identical sign was built for the Stateline Hotel and Casino. The sign is 46 feet tall. Originally, both of the cowboy's arms moved up and down. In 2002, the sign was put in storage and then donated to the city in 2004. In 2005, the sign was restored and installed as part of Wendover's welcome sign.

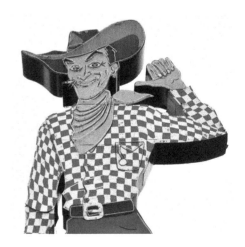

Right: One other sign was modelled after Vegas Vic. The River Rick, aka Laughlin Lou, sign was built in 1981 by YESCO and installed at the Pioneer Hotel & Gambling Hall in Laughlin, Nevada. Both of his arms move up and down.

This special sign type has no official name. Like 'skeleton signs', which are installed inside store windows, these signs are composed entirely of neon 'bones' supported by a metal grid. For lack of any better term, I have taken to calling these sign accents 'neon extensions' since the tubing projects away from the sign panels. These nearly free-standing neon pieces are more than just border details surrounding the sign. Pointing arrows are the most common subset of this sign type. Nearly as common are the ubiquitous neon cocktail glasses, which are commonly perched on top of sign panels. Other surviving neon extensions include stars, hearts, flowers, horseshoes, flames, musical notes, doughnuts, and dollar signs that follow the contours of the sign panels. Frequently, these shapes were sequentially lit with flashers. A handful of jewellery stores have shimmering diamonds with neon tubing rays. Several drug stores have mortars with moving pestles which are composed entirely of neon tubing. What makes these sign additions significant is their miraculous survival considering the vulnerability of the exposed tubing to weather and vandalism. They are two-dimensional neon sculptures reflecting the skill of the tube bending artists who created them.

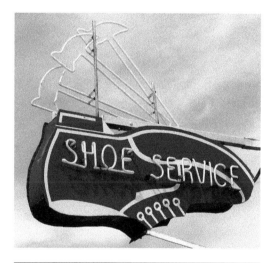

The Blue Ribbon Shoe Service sign in Grants Pass, Oregon was originally located in Roseburg, Oregon. It was built around 1947 and was the first neon sign in town. When that shoe repair shop closed in the mid-1990s, the owner of the Blue Ribbon bought it. He had the sign repainted and restored. The shoe was originally painted brown. The flashing mechanism has broken many times in recent years but the owner has not given up. The sign is about 4 feet wide.

The Brad's Bar-B-Q sign in Moscow, Tennessee was built for Lewis' Bar-B-Q in 1963. When Brad's moved into the building in 2005, the plastic box panels were changed to reflect the new name. This neon extension above the sign was kept. It is about three feet tall. At first glance, the neon appears to represent a little girl with pigtails. However, a closer look reveals a pig-like snout instead of a nose. The owners of both restaurants refer to the figure as the 'girl pig' and the 'pig head'. The neon was originally pink and blue. When Brad's opened, the neon was repaired and changed to red and blue.

Left: The Jackson's Liquor sign in Oakland, California was built in the 1950s. It is about 15 feet tall and features a bottle pouring entwined neon into a glass. The sign is still lit at night. The text is lit with white and red neon. The bottle is blue and red, while the glass is green. The pouring liquid, which was probably animated originally, is represented with red tubing.

Below: The Last Chance Liquors sign in Nashville, Tennessee was built for the store when it opened in the early 1950s. The arrows originally flashed on and off sequentially. The red bulb arrow was probably added in the early 1960s. The neon has not been lit since the 1990s. The name Last Chance refers to the fact that, at the time when the business opened, it was the last liquor store heading out of town going towards Louisville.

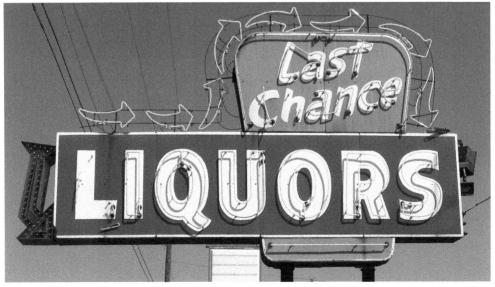

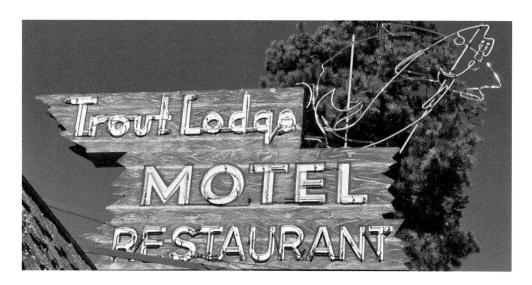

The Trout Lodge sign in Naches, Washington features simulated wooden planks and a trout that leaps in two-part animation. The neon text is white, red, and green while the trout is lit with red tubing. The sign, which is about 7 feet tall, was installed between 1957 and 1965. Around 1996, the sign was blasted by snow blowers and the neon was broken. When it was restored, the word 'cafe' was changed to restaurant.

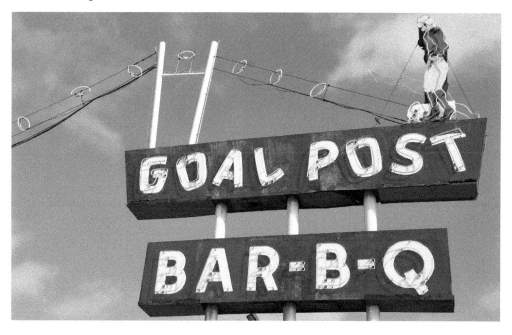

The Goal Post Bar-B-Q sign in Anniston, Alabama was built in the mid-1950s. It features a larger-than-life football player kicking a football over a goal post. The kicker's leg moves in three phases. What makes this sign particularly unique is the neon footballs, which were strung by wires over the parking lot between the kicker and the restaurant's roof. The sixteen footballs, which are sequentially lit, create the illusion of an arching and tumbling ball. In 2013, the Goal Post closed. In 2014, the sign was restored and reinstalled at Betty's Bar-B-Q in Anniston. The string of footballs leading to the restaurant was also restored.

Some of the country's biggest signs were installed on rooftops where they could be seen from great distances and a variety of approaches. They are often referred to as scaffold signs since they are attached to immense and visible steel and iron trellises. Some of these signs are simply oversized sign panels but most of them have free-standing letters outlined with neon and/or bulbs. Because of their size and omnipresence, many of these signs have become city icons and have been maintained long after the businesses that they advertised have folded. Other long-neglected rooftop signs remain simply because they would be too costly to remove. The most common rooftop signs advertised for hotels in downtown areas. They usually had street level neon signs as well.

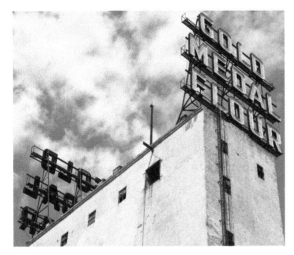

The Gold Medal Flour signs in Minneapolis, Minnesota are installed on the roof of the concrete grain silos of the Gold Medal Flour Building. The building now houses the Mill City Museum. The original signs were installed on the roof around 1906. In 1924, the signs were updated to read Gold Medal Foods. They were changed back in the early 1930s. In 1945, the signs were renovated and updated. These are the signs that appear today. They are 45 feet tall and 42 feet wide. The letters are about 8 feet tall. The signs are lit at night and the letters flash. The signs' restoration in 2000 cost about $250,000.

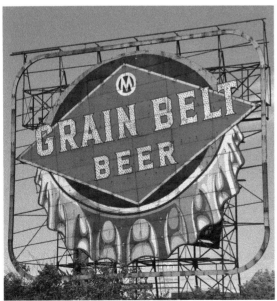

The Grain Belt Beer sign in Minneapolis is 50 feet wide and 40 feet tall. It has approximately 1,400 light bulbs and about 900 feet of neon tubing. It was built in 1941 and installed on the roof of the Marigold Ballroom. In 1950, when the ballroom was about to be demolished, the sign was moved to its current location on Nicollet Island next to the Hennepin Avenue Bridge. The letters flashed in sequence until the brewery closed in 1970. The sign was restored and relit in 1988 but it went dark around 1994. In 2014, the sign was purchased by the August Schell Brewing Co., which plans to restore the sign. The neon will most likely be replaced with LED tubing. The restoration is expected to cost around $500,000 and will be completed in 2017.

Bardahl Manufacturing was established in Seattle, Washington in 1939. The company produces oil and gas additives. This animated sign was built by Campbell Neon in 1952. It is about 15 feet wide. At night, the red neon alternates between 'Add Bardahl Oil' and 'Add it to Your Gas'. The sequentially lit white neon rings create the illusion of an approaching car's headlights. When the headlights reach the top of the sign, the green outline of the car's front end is seen.

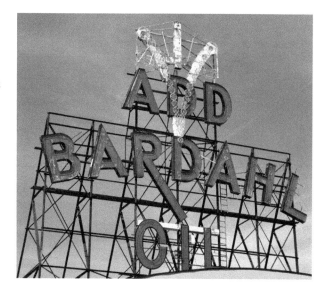

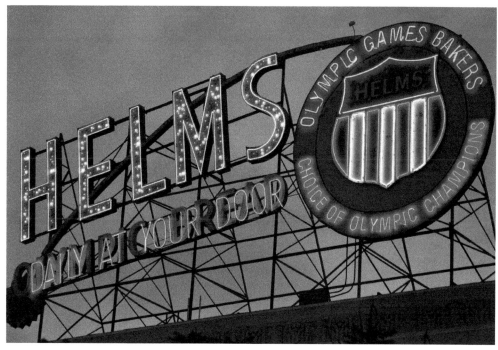

The Helms Bakery Building in Culver City, California was built from 1930–1. This sign was built then. The text refers to the company's designation as the 'official baker' for the upcoming 1932 Summer Olympic Games in Los Angeles. Helms bread and baked goods were never sold in stores but rather through panel trucks throughout Southern California. The delivery truck would sound a whistle announcing its presence as it drove through residential neighbourhoods. The company's slogan was 'Daily at Your Door'. The text on the sign switches back and forth between that slogan and 'Olympic Bread'. The sign features spectacular animation including a starburst on the left and twinkling stars on the shield. Helms folded in 1969. The complex now houses furniture showrooms, art galleries, restaurants and retail stores. The animated rooftop neon sign was restored and relit in 2003.

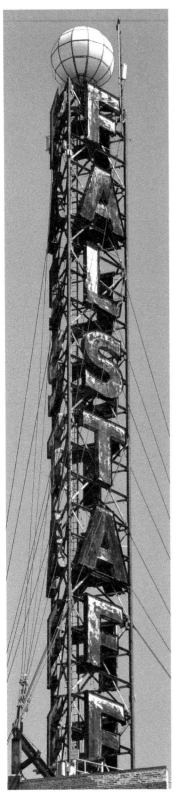

Weather beacons and weather balls were particularly popular in the 1950s and 1960s. Dozens of them were built in the United States and other countries. Several are still operating. These rooftop sign additions changed in colour to reflect the current weather forecast.

Left: The former Falstaff Brewery in New Orleans, Louisiana features a 185-foot-tall sign tower. It was built in 1952 and its weather ball operated until the brewery closed in the 1970s. The building remained vacant until 2007 when it was converted into apartments. This photo precedes the sign's restoration in 2011. The 11-foot-tall steel letters were replicated. The tower and weather ball are lit in the same weather-predicting colour patterns as they were originally. The letters indicate changing temperatures. When they are lit from bottom to top, it means temperatures are rising. When lit from top to bottom, temperatures are falling. When the letters flash, no change is expected. The sign's weather ball is lit with green, red, and white neon to predict rain, showers, approaching storms, cloudy, or fair weather.

Below: The Citizens Bank sign in Flint, Michigan was installed in 1956. At night, the weather ball forecasts changing temperatures with red for hotter, blue for colder, and yellow for no change. The ball flashes when rain is predicted. The ball is 15 feet in diameter. In 2013, after this photo was taken, FirstMerit Bank replaced the neon 'CB' panels with backlit plastic 'FM' panels. The weather ball still operates.

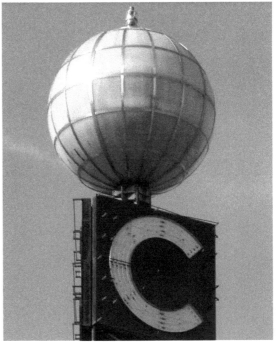

In 1957, the Soviet Union launched Sputnik, the first man-made satellite. The United States responded the following year by sending the Vanguard satellite into orbit. The Space Race was on and the stars and starbursts used in signs by the mid-1950s became even more prominent.

Roto-Sphere signs are perhaps the biggest and most dramatic neon signs ever mass produced. They were created and produced by Warren Milks from 1960–1971. Milks made approximately 234 of them and only about eighteen are left. Of these, only four are fully operational. Roto-Spheres were promoted as sign add-ons and distributed nationwide, with a few sent outside the country. Contrary to what many people say, Roto-Spheres were not inspired by the Russian Sputnik, other satellites, or anything space-age. Milks got the idea for the design from something he saw on TV, possibly a commercial for a children's toy or a spinning Christmas ornament. When people began calling his signs 'Sputniks', Milks began using the name himself. However, the signs were always marketed as Roto-Spheres. They feature sixteen aluminium spikes outlined in neon. These spikes are each 8 feet long. Not only does the sign rotate on its pole, but the steel ball at the centre is composed of two counter-rotating hemispheres.

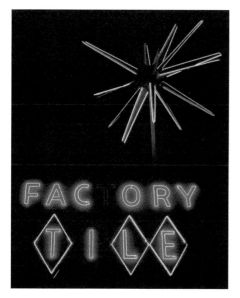 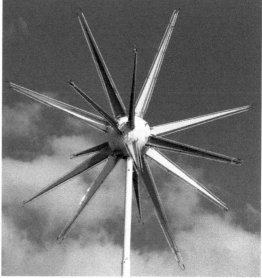

Above left: The Factory Tile Roto-Sphere in South Bend, Indiana does not spin but the multi-coloured neon still works. When it stopped rotating around 1979, the company decided it was too costly to repair. However, the neon is maintained and the diamonds around 'TILE' flash on and off.

Above right: The Jerry Dutler's Bowl Roto-Sphere in Mankato, Minnesota was installed in 1965 when the bowling alley opened. In 1980, the motor gave out and it was not replaced. Dutler's restored the sign in 2007 with multi-coloured neon. In 2015, the bowling alley closed. In 2016, the building began housing the Vintage Mall. The owner may change the panels beneath the Roto-Sphere from BOWL to MALL.

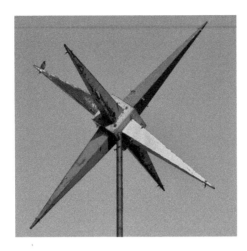

This sign in Elkhart, Indiana is an example of a Neo-Lectra. The six metal spikes were originally outlined with neon. These signs measure 13 feet across and were stationary. They were installed on a pole above the businesses' main signs. Neo-Lectras were designed and manufactured in the 1960s by Jim Henry of Oklahoma Neon. The Standard Neon Supply Company distributed the signs. There may have been 100 or so of these made but there are only about nine left on public display. The sign in Elkhart is installed above the sign for Tops Home Center, a mobile home sales business that is now gone.

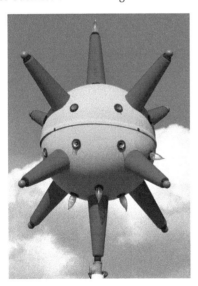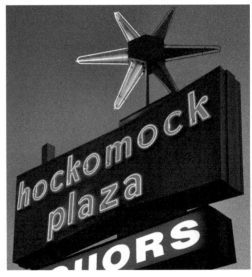

Above left: The sign-topper was also mass produced. The manufacturer is not known but there are about a dozen of these signs known to exist. They were made in two sizes: about 5 feet wide and about 7 feet wide. The larger ones have more bulbs. This sign is located in Las Cruces, New Mexico at an unidentified business.

Above right: The Hockomock Plaza sign in West Bridgewater, Massachusetts was built in the early 1960s. It is topped with a Neo-Lectra Jr. These pinwheel-shaped signs were also designed by Jim Henry and marketed by Standard Neon. Smaller than the Neo-Lectra model, these signs revolved. It is believed that only a handful of these were made. This is the only one known to still exist. It has not revolved since at least 2001. The white-painted star is lit with green, blue, orange, pink, and white neon.

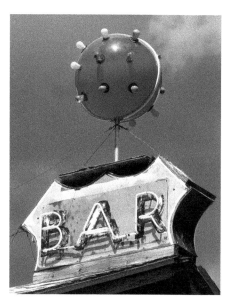

These red globe signs were produced in the 1960s by National Outdoor Display of Memphis, Tennessee. They did not revolve but the bulbs flashed in a quick pattern. There are about two dozen of them still on display around the country. Some have been painted different colours. Some have long clear bulbs, long and short clear bulbs, clear and coloured bulbs, or all coloured short bulbs like this one at the Corral Bar in Gallatin Gateway, Montana. This sign has been here since at least the early 1970s. The flashing mechanism was repaired in 2017.

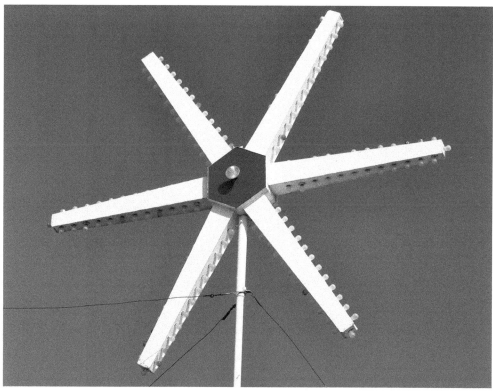

This C-152 Lectra sign is installed at the Fun House Pizza location in Raytown, Missouri. These sign-toppers were marketed by Standard Neon Supply in St Louis, Missouri. There are about a dozen of these signs scattered around the country. They are 12½ feet wide and have 152 bulbs that flash from the inside to the outside of the arms. The one in Raytown is the only one still operating. It was installed at the pizza shop when it opened in 1964. It has always operated and was refurbished in 2014.

In the 1950s, sign makers began using plastic materials in sign construction on a regular basis. By the late 1950s and early 1960s, signs were commonly produced with combinations of neon and plastic. By the late 1960s, backlit plastic signs had become standard. These signs were lighter, easier, and cheaper to produce. Part of the trend can be attributed to Rohm and Haas' invention of Plexiglas, a shatterproof acrylic material that it developed during the Second World War. After the war, Rohm and Haas mass produced signs for gas stations, retail stores, restaurants, banks, and other businesses.

Plastic signs are not as highly valued as neon signs. Many wonderful one-of-a-kind plastic signs have been nonchalantly cast aside by business owners who believed they were not worth anything. Since they can be easily removed and discarded, plastic signs are disappearing at a faster rate than heavier neon signs. In addition, many mid-century plastic panels have become brittle and often shatter during their removal.

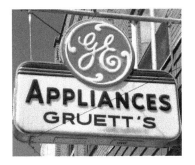

Gruett's Appliance Center is located in Merrill, Wisconsin. This sign was installed in the 1960s and is still lit at night. These General Electric Appliances signs were mass produced and customized with the name of the business. This practice was used by many other companies. There are still dozens of these vacuum-formed signs still on display advertising for Frigidaire, Pittsburgh Paints, Sherwin-Williams Paints, various soft drink companies, and other brand names.

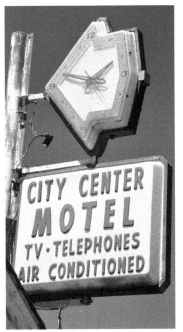

Vacuum-formed panels are created by heating plastic sheets over a mould. A vacuum pulls the plastic sheets and stretches them over the mould creating an embossed surface. Usually, this was done for high-volume production signs since the moulds were costly. However, some sign companies used moulds with stock letters, which could be used for one-of-a-kind signs as well.

The City Center Motel sign in Burns, Oregon features a plastic clock and vacuum-formed panels. These arrow clocks were produced in the early 1970s by Superior Outdoor Display in Long Beach, California. They came in many different colours and pointed downward or sideways. There were a few thousand made but there are about a dozen of them still on display around the country.

In the 1950s, sign companies began producing corrugated metal and plastic sheets. These sheets were, thinner, lighter and still held their shapes. Letters and shapes were cut by hand and glued down onto these sheets. This method of sign panel production was quicker and more affordable. Frequently, these plastic panels were used in conjunction with neon or bulb elements. By the mid-1960s, neon signs were still being produced but plastic signs were far more common.

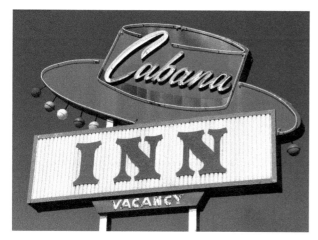 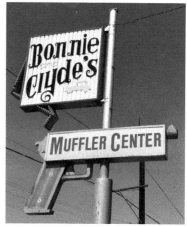

Above left: The Cabana Inn sign in Boise, Idaho was installed in the late 1950s or 1960s. Originally, the hat was painted black and the plastic letters read MOTEL. The open channel letters and the hat's outline are lit with red neon. The plastic panel is still backlit. The plastic tassels were probably internally lit originally.

Above right: The Bonnie and Clyde's Muffler Center in Yakima, Washington opened in 1967. This sign was built then. The name came from the movie *Bonnie and Clyde*, which was released earlier that year. The plastic panels are original. The gun is metal. The bulb arrow may have flashed.

Below: The Sportsman's Lounge in Wahpeton, North Dakota opened in the early 1940s. This sign was built in the 1950s or 1960s. This backlit plastic background material was referred to as dimpled, egg carton, and 'awful waffle' by sign companies. It was used far less often than the corrugated type. This photo is from 2011. In 2013, the bottom panel was broken in a hailstorm. It was replaced with a flat plastic panel with painted letters of a different typeface. The sign company told the owner that the original dimpled plastic material was no longer made. The neon around the shield stopped working around 2015. The bar owner got an estimate for about $3,000 to replace the transformer. He is hoping to get a matching grant from the city in the future to repair it.

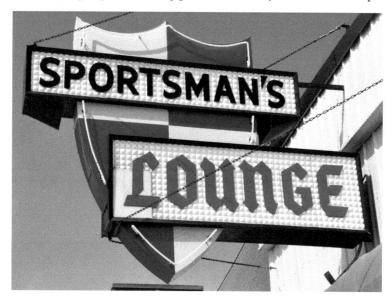

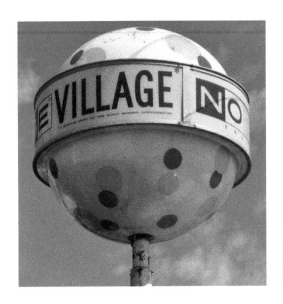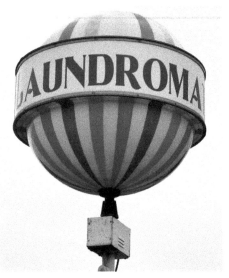

These Norge Village Cleaners signs are commonly called 'Norge Balls'. They were created by Rohm and Haas in the early 1960s. These plexiglas signs are about four feet in diameter. They were internally lit and revolved. In 1967, there were 3,400 Norge Village locations. Most of them probably had these signs. There are roughly sixty Norge Balls still on display. Some of them have been repainted for other businesses. Many of them are abandoned and in poor, broken condition. While most of these signs have polka dots, a few have stripes and bear the Norgetown name. The sign on the left is located at Hart's Best Dressed Dry Cleaners & Laundromat in Roy, Utah. The sign on the right is at the Washboard Coin Laundry in Iron Mountain, Michigan. It is the only Norge Ball that still spins and is backlit at night. The bearings were replaced around 2007, but it has the original motor.

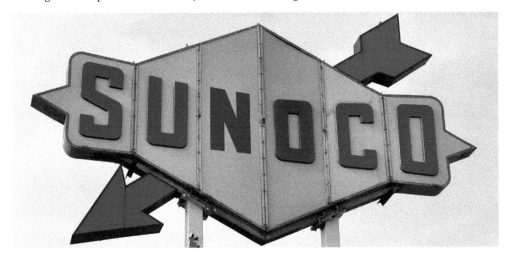

This Sunoco gas station sign in Southfield, Michigan is about 15 feet wide. It is composed of six plexiglas panels stitched together on each side. The only other sign like this known to exist is in Huntington, West Virginia. Both of these signs are at still operating Sunoco stations. Should the branding change, most likely these signs would be removed. These signs were probably built in the 1960s by Rohm and Haas, which produced many other gas station signs and smaller Sunoco signs like this.

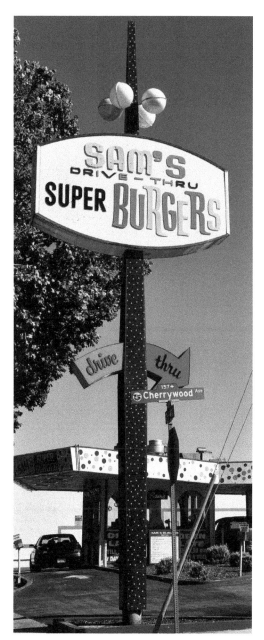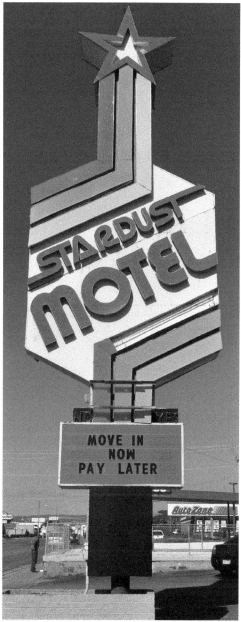

Above left: This Sam's Super Burgers is located in San Leandro, California. It was built in 1974. The sign is about 30 feet tall. The panels and balls near the top are all backlit plastic. There is another location in San Lorenzo which has an identical double drive-thru building. It probably had a sign like this originally. There may have been other locations in the Bay Area.

Above right: The Stardust Motel in Rapid City, South Dakota opened in 1971. After the Black Hills Flood of 1972, the Stardust moved to its current location at the former Impala Motel. It reopened in 1974 and this backlit plastic sign was erected in 1975. The letters closely resemble the font used for the original *Star Wars* movie, which was released in 1977. The 'ST' is an exact match. The sign is about 20 feet tall. It is no longer lit.

People

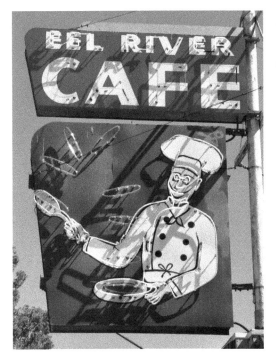

Left: The Eel River Cafe in Garberville, California opened around 1931. The owners believe that this two-part sign was installed in 1952. The chef panel is about 8 feet tall. The sign is still lit in the morning with blue, red, white, and pink neon. The animation of the pancakes still works but it is impacted by cold weather.

Below left and right: The Pete's Kitchen sign in Denver, Colorado was installed by the 1950s. The restaurant has gone by many names since it first opened around 1936. By the 1940s, the name had been changed to Bill's Kitchen. By the 1960s, it had been renamed The Kitchen. It is not known if the current sign was installed by Bill's Kitchen or by The Kitchen. It's possible that the lower text part of the sign may have been installed first. By the 1960s, however, both parts of the sign were definitely there. In 1988, the restaurant's new and current owner, Pete Contos, had the 'The' on the sign replaced with his own name. The sign is about 10 feet tall. The pancakes were originally animated but have been static for decades.

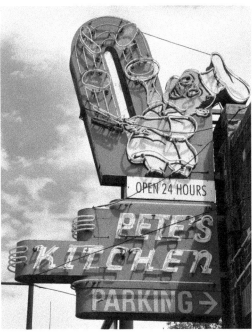

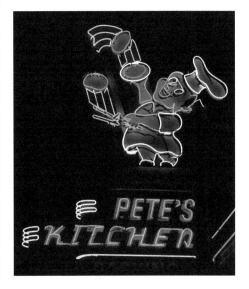

Right: The Original Pancake House in Seattle, Washington is part of a chain of restaurants. This sign was built around 2001 in a vintage style when that location opened. The chef is made from porcelain enamel panels commonly used for signs from the 1940s and 1950s. The four neon pancakes that hover above the chef's pan are lit sequentially. The text part of the sign is made with backlit plastic panels.

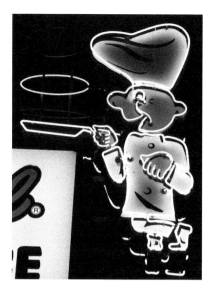

Below: The Pancake Chef opened in SeaTac, Washington in 1959. This pole sign was installed then. It is about 20 feet tall and features Mondrian-like boxes, plastic panels, and a neon arrow. The vertical chasing bulbs still operate. The chef character still appears throughout the pages of the restaurant's menu.

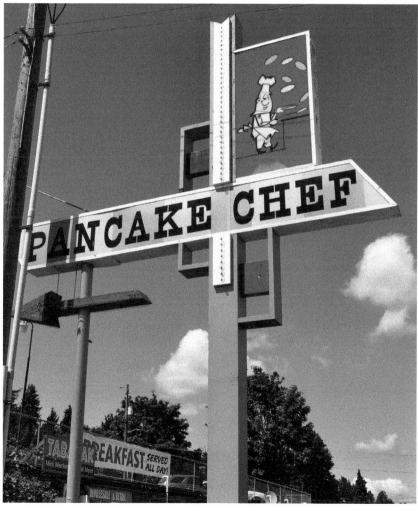

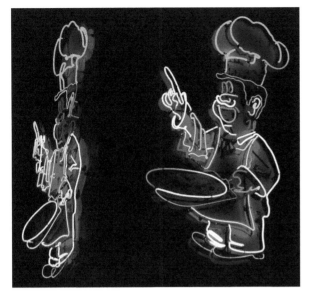

Victorio's Ristorante in North Hollywood, California opened in 1964. Neon chefs were installed on the building then. These chef signs replaced them in 1995. They are about 5 feet tall. The two identical signs were installed on the corner of the building. The chefs' right hands flashed on and off. In 2017, these signs were replaced with backlit plastic versions. According to the owner, the neon signs will be placed on the back of the building after they are repaired.

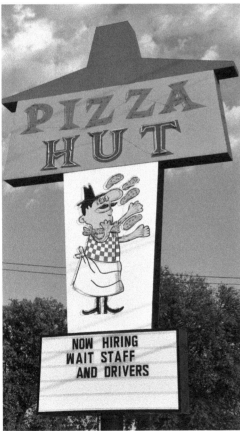

This Pizza Hut sign in San Antonio, Texas was built around 1969. It may have been the only sign ever built like this. In the late 1960s, Pizza Hut was producing very similar plastic signs with the chef but with only one pizza in mid-air. The chef character is known as Pizza Hut Pete. He began appearing in Pizza Hut advertising in 1963. The character was used on non-neon signs on the roofs and fronts of the company's restaurants through the 1970s.

When this restaurant moved to a new building in 1999, this sign was brought along. The location loses points during corporate inspections for having non-conforming signage. However, the sign is allowed to stay if it is impeccably maintained. Not including the pole, the sign is about 25 feet tall. The Pizza Hut Pete portion is about 10 feet tall. According to the owner, the sign has more than a hundred pieces of red, white and blue neon. Pete's left hand moves up and down while the pizza sequences through four positions. The top of the sign mimics Pizza Hut's hat-like roof design of the 1960s. The sign has been repainted a couple of times. Around 2009, the sign panels were covered with laser photo sheets which should require less maintenance.

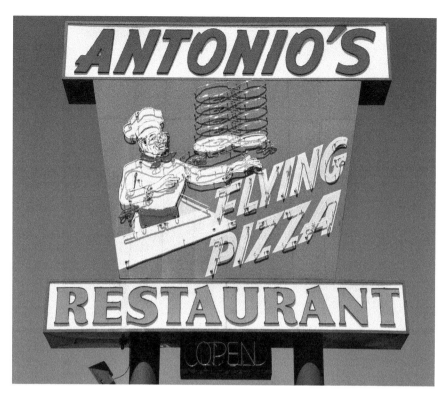

The Antonio's Flying Pizza sign in Houston, Texas is 20 feet tall and installed on 20-foot-tall poles. Both of the chef's arms are animated and move to spin and hoist the pizza. The pizza is lit sequentially in six positions. Antonio's opened in 1971 and this sign was installed then. There were four other signs like this built for Mario's Flying Pizza. Mario was Antonio's brother-in-law. Those signs are all gone now.

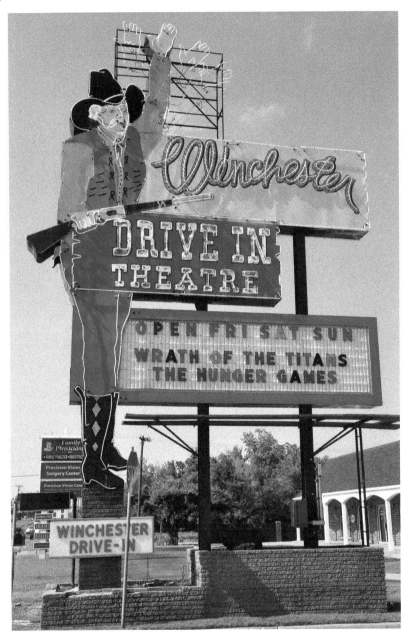

The Winchester Drive-in in Oklahoma City, Oklahoma opened in 1968 and is still operating as a single screen. This neon sign has been here since the beginning. It features a 35-foot-tall cowboy holding a Winchester rifle. As far as anyone knows, he was not modelled after anyone. The sign's paint and six neon colours are original. The cowboy's arm still waves in five-part animation. In 2010, the sign was damaged by hail and the neon was replaced. The ticket booth at this drive-in is also decorated with neon.

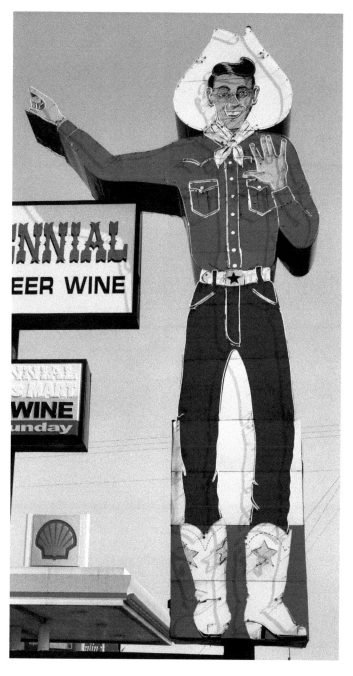

This 38-foot-tall sign was built in 1958 for the Big D Value Mart in Dallas, Texas. The store got permission from the Texas State Fair to use its character of Big Tex for the sign. When the Big D Value Mart closed in 1962, the sign was sold to Centennial Liquors in Dallas. The lettering was changed at that point. In 1985, the sign was toppled by high winds. It was rebuilt using mostly original parts. In 1993, the sign was moved to another Centennial location. That store closed in 2012. The sign's neon was restored in 2013 for the filming of an AMC TV pilot, *Halt & Catch Fire*. AMC paid for the restoration with permission from the sign's owner. In 2015, the property was put up for sale. The sign was sold to the State Fair. It has been restored and is now on display at Fair Park in the fall.

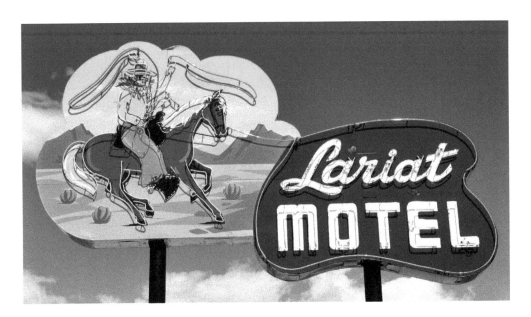

The Lariat Motel in Fallon, Nevada was built in 1953 and this sign is from then. The cowboy's arm and lariat are lit in three-part animation. The neon lariat moves backward, forward, and then encircles the text part of the sign. The motel was demolished in 2005. At that point, the sign was donated to the Churchill Arts Council. In 2013, the sign was restored by YESCO in Reno, Nevada. It is now located at the Oats Park Art Center in Fallon.

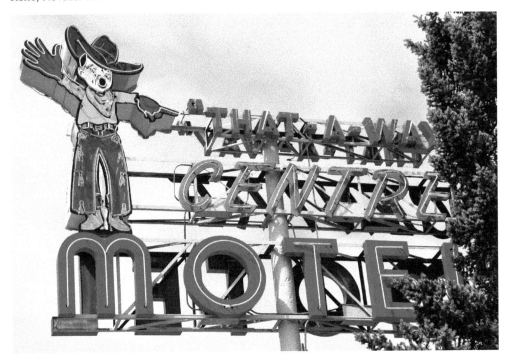

This sign was originally built for the Knapp Motel in Elko, Nevada. By the early 1950s, it had become the Centre Motel and the name was changed on the sign. The motel is set back from the road, hence the 'That-A-Way' and pointing cowboy.

Right: Bronco Burgers opened its first location in Omaha, Nebraska in 1959. This location opened there in 1962. The sign and building are still pretty much intact. The first four locations had this same sign design. However, this is the only one that's left. It is still lit and the cowboy's lasso is animated.

Below: The Branding Iron restaurant in Merced, California opened in 1952. This animated sign was built then by Merced Neon. The cowboy's lasso moves back and forth and encircles the restaurant's name. The brands at the top and bottom of the sign flash on and off. The sign is about ten feet wide. In 1987, the restaurant was damaged by fire and closed. A new owner reopened the place the following year. In order to restore the sign and keep it animated, the sign was designated a historical landmark by the city in 1988. Around 2004, heavy winds destroyed about ninety-five per cent of the neon. The tubing was replaced and the sign was repainted soon after that.

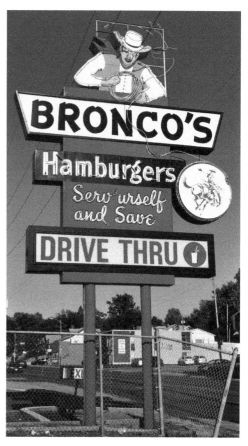

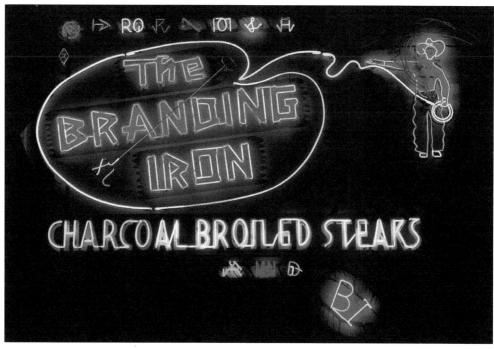

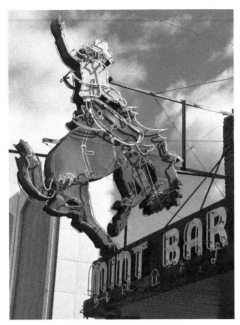

Left: The Mint Bar in Sheridan, Wyoming was established in 1907. This sign was built around 1947 when the bar was remodelled. It was produced by the Sheridan Sign Company and painted by Bernard P. Thomas. The horse and rider panels are about 12 feet tall. They were repainted around 2006. The neon cattle brands around the canopy were probably animated originally.

Below: The South Dakota Stockgrowers Association sign is located in Rapid City, South Dakota. It was built in 1958 by Rosenbaum Signs & Outdoor Advertising. The company continues to maintain the sign. It was restored in 1999 for about $7,500. The sign had been dark since around the 1980s. The panels are original and are about 20 feet tall.

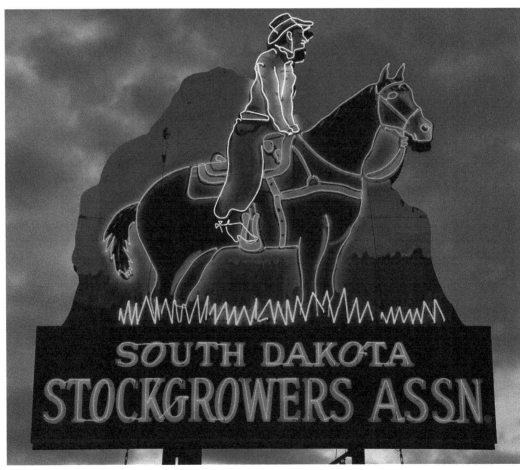

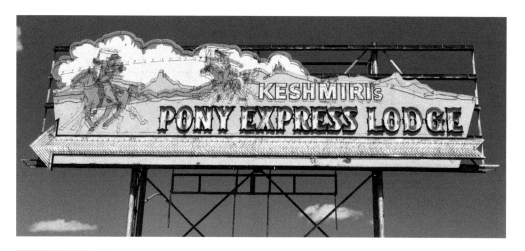

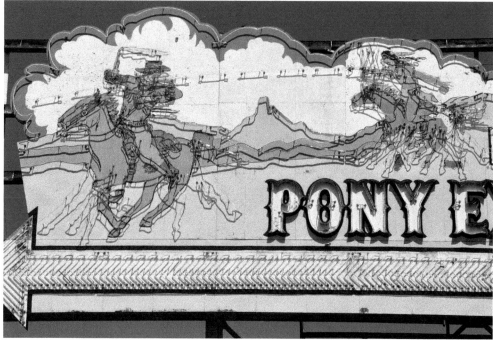

Keshmiri's Pony Express Lodge in Sparks, Nevada opened around 1933 as Cremer's Auto Court. In 1951, the motel became an annex of Harold's Club in Reno and was renamed the Pony Express Motel. This animated, single-sided sign was built then. Its 60-foot-long arrow points at the motel across the street. The sign was designed by Frank N. Stricklan and produced by Cosgriff Neon. The sign originally read 'Harold's Pony Express Motel.' The name 'Harold's' was replaced with 'Keshmiri's' around 1989 when the motel was sold to Joe Keshmiri. The other text on the sign is composed of open channel letters. Channel letters were used for two reasons. The surrounding metal border protected the neon tubing from vandalism and weather. In addition, the neon letters were more defined. Most vintage signs from the 1940s and 1950s have the neon installed directly on the panels. When the signs are lit, the glow of the tubing is reflected onto the panels. The Pony Express sign is no longer lit. It had red, gold, blue, white, and green neon. The horses' legs and the Indian's arrows were sequentially lit. The sign is not landmarked in any way and there are no plans to restore it.

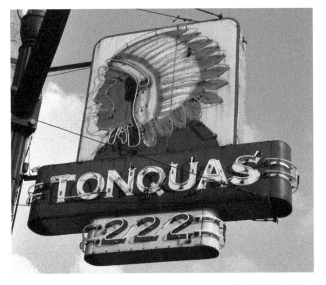

The Tonquas Tribe Club in Troy, Ohio is part of the Improved Order of Red Men fraternal organisation. This sign is probably from the late 1940s or 1950s. The red, green, and blue neon tubing was restored in the early 2000s.

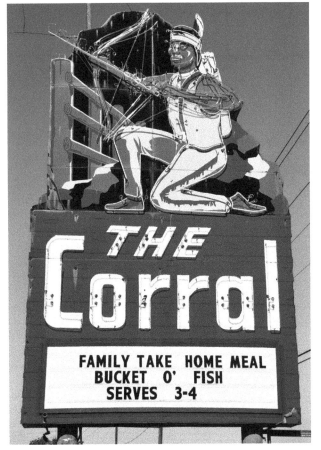

The Corral restaurant opened in Victoria, Texas in 1952. This neon sign was installed then. This animated sign features an Indian firing off five flaming arrows from his bow. The arrows extend away from the sign via a wire to the roof where they burst into a neon flame. The only other sign that has neon attached to a wire extending to the roof is the Goal Post sign described on page 19.

In 2015, the Corral closed. In 2016, the QP Smokehouse at the Corral renovated the building and opened there. The sign remains the same and is lit at night.

The Navajo Hogan Roadhouse in Colorado Springs, Colorado was built in 1935. A neon sign was installed on top of the roof at that time. It was blown off the building in the early 1940s. It was replaced with this sign in the late 1940s or early 1950s. During the Second World War (1939–1945), very few signs were produced since steel was needed to build tanks, ships, planes, and weapons.

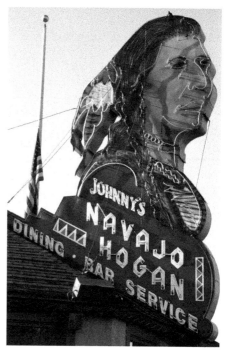

This 17-foot-tall sign was built by the Cimino Sign Company. It has been restored at least twice. In 2011, the restaurant/bar's new owner added the name 'Johnny's' to the sign. The faded sign was also repainted at that time. It is lit with red, green, blue, and white neon. One unusual aspect of the sign is the way the panels were built to fit the slant of the roof. Normally, signs were built with flat bases and angled steel supports would have been constructed to install the sign on the roof. Perhaps after this business' first sign blew off the roof, the owner wanted it to be as securely mounted on the roof as possible and less subjected to wind. Several wires and anchors also hold the sign in place.

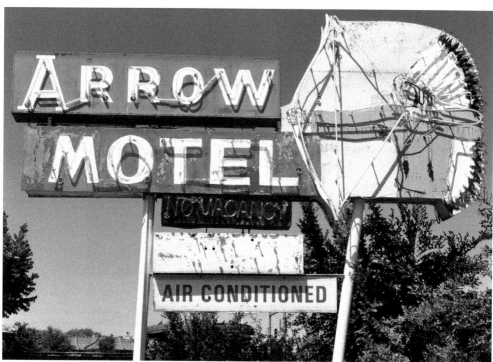

The Arrow Motel in Espanola, New Mexico has been closed for decades but this sign remains. It was probably built in the 1950s and had blue, red, green, and white neon. The Indian's bow was lit in four-part animation. Two neon arrows between the two text panels were sequentially lit.

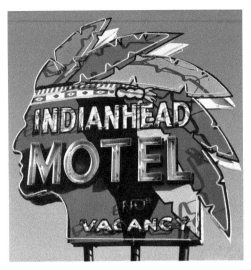

Left: The Indianhead Motel in Chippewa Falls, Wisconsin opened in 1958 and this sign was installed then. There were two parts below this sign which were removed around 1990: a tomahawk that read 'Television' and an arrow which read 'Air Conditioned'. The sign was repainted in 2008. It is about 7 feet wide and is lit with red neon.

Below: The history of this sign at Robson's Arizona Mining World in Aguila, Arizona remains a mystery. It might be from 1992 or it could be much older. The metal panels are about 15 feet tall and pierced with bullet holes. The sign apparently never had neon. The text panels below are made of wood.

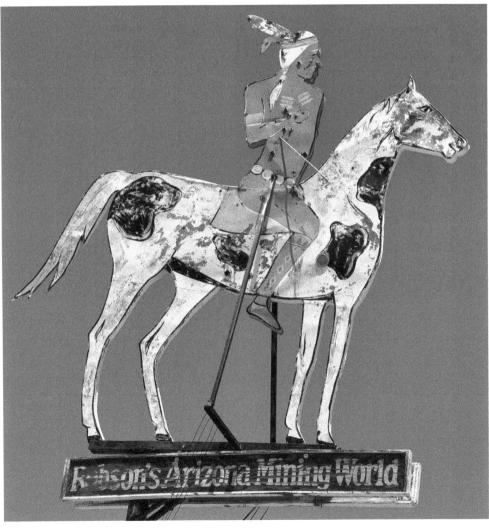

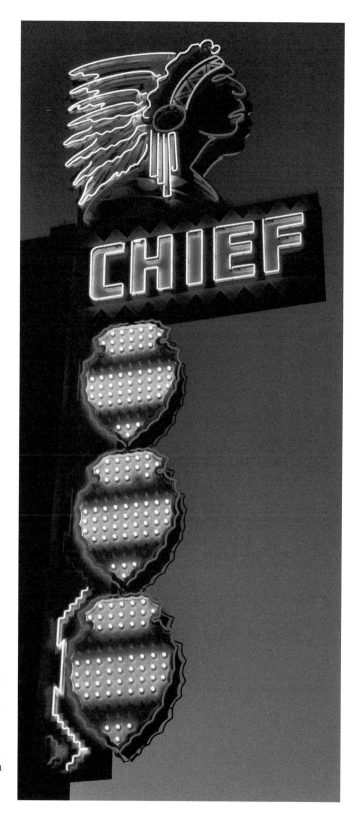

The Chief Theatre in Pocatello, Idaho opened in 1938. It had closed by 1984 and was donated to the city. Volunteers spent almost ten years restoring the theatre before it was destroyed by a fire in 1993. The only things that could be saved were the neon sign and the mosaic of the Indian near the entrance which was installed in 1949. The site was turned into a parking lot. In 2013, the sign was restored and placed on a pylon in its original position and height.

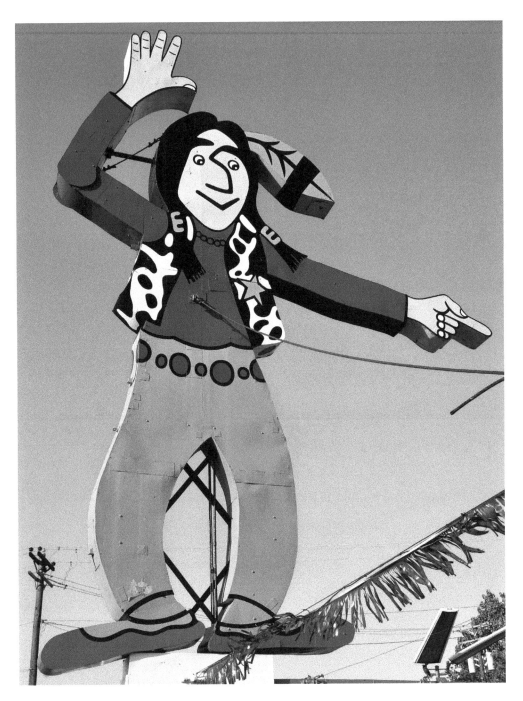

The Chief Pontiac sign in Cincinnati, Ohio is installed in front of MotorTime Auto Sales. The sign was built in 1954 for Jake Sweeney's Pontiac dealership. The business was later known as Cherokee Motors. MotorTime has been here since 1981. The Indian sign was originally outlined with neon and the arm waved. Although many sources say that the sign is 50 feet tall, it is much shorter than that. The Indian is about 15 or 20 feet tall. The sign has been repainted a few times. While it has been said that these signs were produced by General Motors for other Pontiac dealerships, there is no evidence of that.

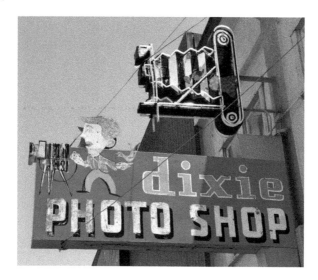

The Dixie Photo Shop in St George, Utah closed in 1999 but this sign remains. The lower sign was already in place when T.P. Durrant took over the business around 1963. The painted metal sign was probably built in the 1950s and may never have had neon. The upper sign came from Odegard's camera store just a couple of blocks away. When that store closed, Dixie Photo adopted the sign and installed it above theirs. This sign is most likely also from the 1950s. The neon may still be functional but the sign is no longer lit. Durrant's son says that the city of St George would like to see these signs taken down. However, since he owns the building and they have been there so long, the signs are legally allowed to stay.

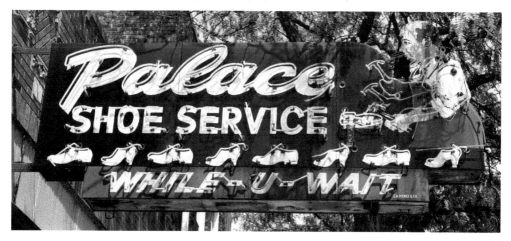

The Palace Shoe Service in Rockford, Illinois was established in 1926. The name came from the nearby Palace Theatre, which was demolished in 1984. This sign was built in 1950 and is about 8 feet wide. It was moved from a previous location to the current store. The cobbler on the sign represents the owner at that time, John Antunicci. When the sign was lit, the cobbler's arm moved in three-part animation. Two red neon sparks lit up when the hammer hit the shoe. The current owner has received estimates of $15,000–$20,000 to restore the sign, which is way more than he can afford.

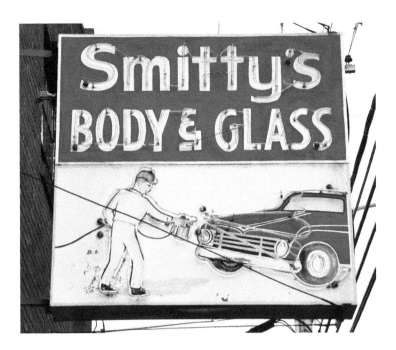

Smitty's Body & Glass was established in Parsons, Tennessee in 1921, making it the oldest business in town. The shop's neon sign was built in the late 1970s as a surprise birthday present for the owner, Ralph Leon Smith, aka Smitty. Den-Ray Sign of Jackson, Tennessee produced the sign from a drawing created by the owner's son. It features a depiction of Smitty spray painting a car. The man and car are outlined with white neon. Red neon is used for the text and the spray, which flashes on and off. The sign is about 5 feet wide.

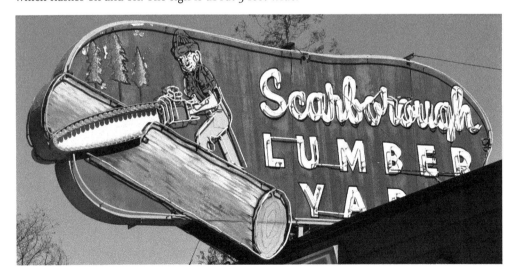

The Scarborough Lumber sign is located in Boulder Creek, California. It is believed to have been built in the 1940s for Santa Cruz Lumber. In 1985, the store became Scarborough Lumber and the name on the sign was changed at that time. In 2008, the sign was repainted and the neon was restored. However, it was only lit for a few years. The owner became frustrated with the transformers which kept blowing out. When the sign operated, the neon was static. The bulbs on the chainsaw were lit sequentially to create the appearance of movement. The sign is about 15 feet wide.

This sign previously advertised for Bill Williams Welding which opened in Long Beach, California in 1945. The sign may have been built then. C.W. Services bought the business in 2001. The sign has not been lit since at least that time. There are no plans to restore it. The sign is about 10 feet tall and is perched on top of a billboard installed on the roof.

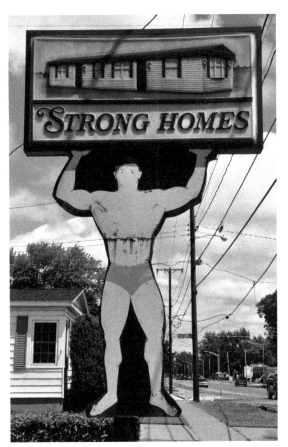

Strong Mobile Homes in Erie, Pennsylvania was established in the early 1940s. This sign is believed to be from the late 1950s. The sign was moved to this location around 1981. The vacuum-form plastic panels on the top of the sign were replaced at that time. The original panels depicted an older model mobile home and had neon. The metal strong man panels are original. James Blose, a local junior high school teacher, was the model for the strong man. The business is planning to repaint him in 2017.

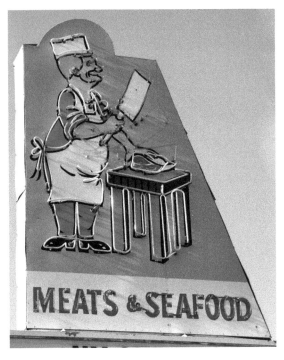

The Braunger Steak Company sign is located in Sioux City, Iowa. When the store moved to its new location around 1982, the sign from the previous tenant was adapted. It originally had oranges, bananas, and other produce. The butcher was modelled after the store's owner, Paul Braunger. The sign is still lit with the butcher's knife chopping in three-part animation. The neon colours are white, red, pink, yellow, and blue. In 2012, the readerboard beneath the sign with manually changeable letters was replaced with a digital display.

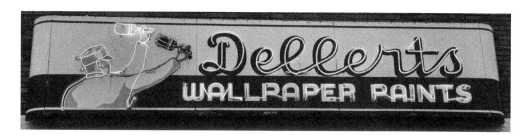

The Dellert's Paint Company sign is located in Springfield, Illinois. Dellert's was established in 1943 and the sign was installed by 1944. It was designed by the owner, Paul Dellert. The sign is about 16 feet wide. The painter's arm moves in two-part animation. The neon has always been maintained.

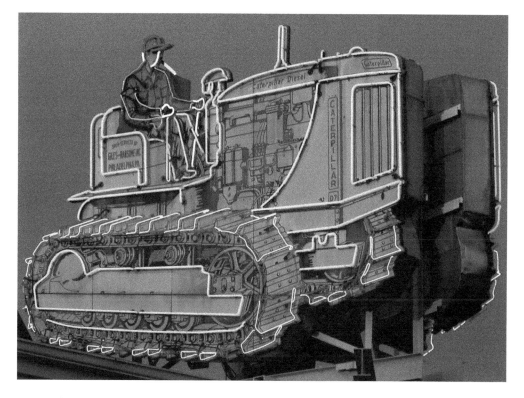

Giles & Ransome in Bensalem, Pennsylvania sells and services construction equipment. This sign was made in the late 1940s for the company's headquarters in Philadelphia. In 1960, the sign was moved to Bear, Delaware but it was vandalized and removed. It was restored in 1999 by Len Davidson and is now at the company's Bensalem facility. The two porcelain enamel sign panels are 13 feet wide and set at slight angles to be visible from both directions on the Pennsylvania Turnpike. There are ninety neon tubes and sixteen transformers. The complex animation features a driver shifting gears. The Caterpillar tractor's treads also move.

There are far fewer representations of women than men on surviving vintage signs. They include provocative women promoting nightclubs, a few drive-in restaurant car hops, a couple of drum majorettes, a few cowgirls and Indian squaws, a hula dancer, a mini golfer in short-shorts, and a Tinkerbelle. In short, this iconography reflects the position of women in American society from the 1940s to the 1960s.

Images of diving women in bathing suits were frequently featured in 1950s motel signs. They symbolically advertised that the business had a pool. Once ubiquitous, there are now less than a dozen left on display. Most of the divers were removed when the pools were filled in with concrete.

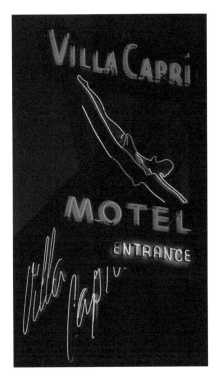 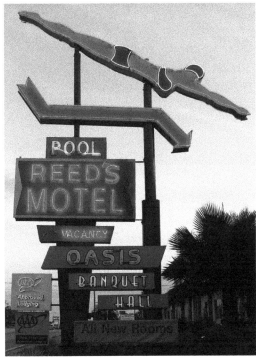

Above left: The Villa Capri Motel in Coronado, California opened in 1956. This sign and the neon on the building were installed then. The sign was designed by the owner, Bettye Trowbridge Vaughen. The diver was inspired by the 'Jantzen Girl', which was used in swimsuit advertising since the 1920s. This motel still has a pool. Maintenance of the neon costs about $4,000 per year. The sign is not operated on rainy nights to keep the transformers from blowing out.

Above right: The Reed's Motel in Avon Park, Florida opened in 1957. This sign is believed to be from then. The diving woman originally wore a one-piece bathing suit. By 2002, the arrow panel had been replaced with a smaller one. In 2004, the sign was badly damaged during Hurricane Charlie. The original diver, which is about 15 feet long, survived. The rest of the sign was rebuilt. The panels' shapes were changed a bit and the arrow was reduced further to about half the size of the original. At the time of writing this book, the motel was contemplating changing the name and selling the sign.

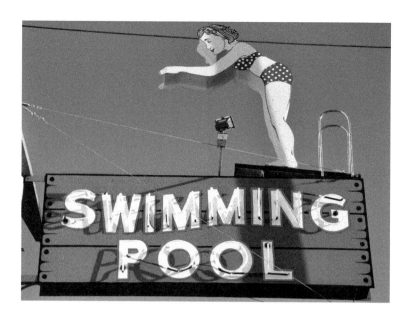

The Pueblo Hotel & Apartments text sign was installed in Tucson, Arizona around 1948. The upper panel with the diving woman was added in 1955 when the hotel's pool was built. The hotel closed in 1984 but the sign remained and deteriorated. The sign had already been dark since at least 1974. When the law firm of Piccaretta Davis bought the building in 1991, the owners wanted to restore the sign. However, Tucson's sign code prevented that from happening until it was revised in 2011. The sign was restored in 2012 at a cost of about $25,000. It was unknown whether the diving woman wore a one- or two-piece suit originally. The law firm decided to depict her in a polka-dot bikini.

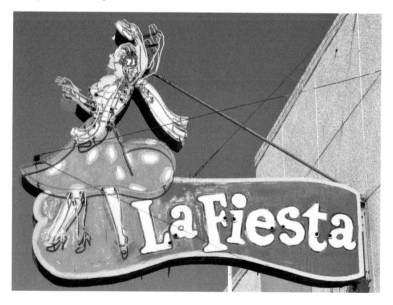

The La Fiesta Nightclub in Fresno, California opened in the 1940s. This sign may be from then or the 1950s. The neon has not operated for decades. When it did, the dancer had animated arms and a leg. Around 2008, the neon was removed from the text part of the sign. The sign is about 7 feet wide.

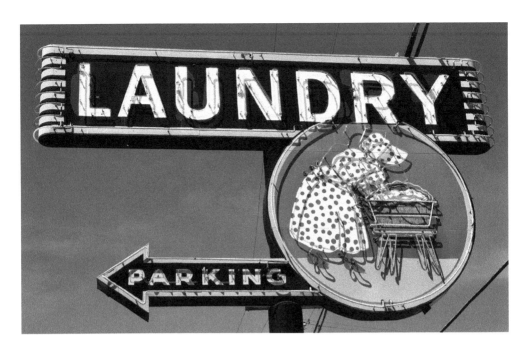

This sign is located at K's Coin Laundry in Yakima, Washington. The sign was one of two identical signs located at Goddard's Appliance in Yakima. These signs were most likely built in the 1950s and probably had different text where 'LAUNDRY' is now. This sign was moved to its current location around 1973. The other sign may have gone to Tacoma, Washington. The Yakima sign was restored in 1993 by Wells Signs for about $6,000. It is lit in three-part animation with the washer woman bobbing up and down. The neon is yellow, green, blue, and red. The sign is about 10 feet long. The owner has spent about $1,000 in the past five years to keep the neon working. Most of the repairs were needed due to rock-throwing vandals.

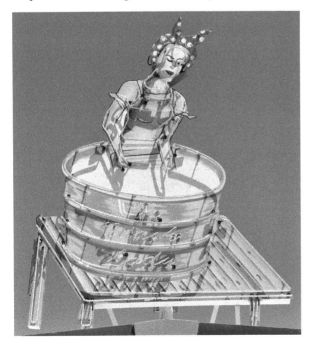

The Boulevard Cleaners sign in Tucumcari, New Mexico was built in the late 1990s. The 'Wash Lady' sign was based on the 1970s painted plywood sign left behind by the previous business, M&M Cleaners. The new owners liked the wooden sign so much that they decided to use the image for their rooftop neon sign. It cost about $7,000. The old sign is still installed on the building directly beneath the new one.

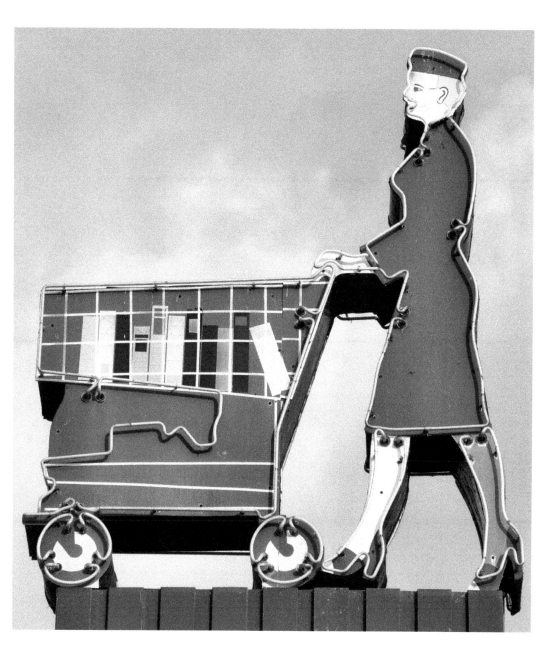

The Schmidt's Super Market in Okemos, Michigan opened in 1958. This sign was installed then. The supermarket closed in the late 1980s. Soon after that, a Barnes & Noble bookstore moved into the building. The sign was repainted and the groceries in the shopping cart were replaced with books. In 2002, Playmakers, an athletic shoe store, moved into the building. The shopping cart still holds books and there are no plans to change that. The sign was originally lit with red neon. It is now lit with green, white, and orange neon. The wheels and woman's legs continue to be lit sequentially to convey rolling and walking action. The sign is about 8 feet tall.

Animals

Birds

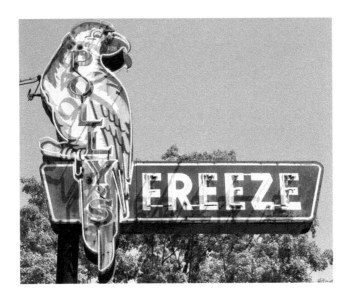

Polly's Freeze in Georgetown, Indiana opened in 1952. This sign was built at that time. The owners, Elmer and Pauline Gleitz, chose the image of a parrot since the wife went by the nickname of 'Polly.' The parrot is similar to the one that appears on Poll-Parrot Shoe signs. The sign has always been maintained. The parrot is outlined with green and orange neon. 'Polly's' is lit with yellow neon and 'Freeze' is lit with pink. The parrot is more than 10 feet tall.

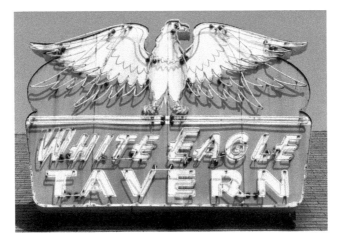

The White Eagle Tavern sign in Riverside, New Jersey is probably from the late 1940s or 1950s. The eagle's wings are lit in three-part animation. The eagle is lit with white neon, while the text below is lit with white and pink. The bar closed in 2015. In 2017, the building was being remodelled for White Eagle Liquors. The sign was restored with the 'Tavern' letters on the bottom of the sign changed to 'Liquors'.

54

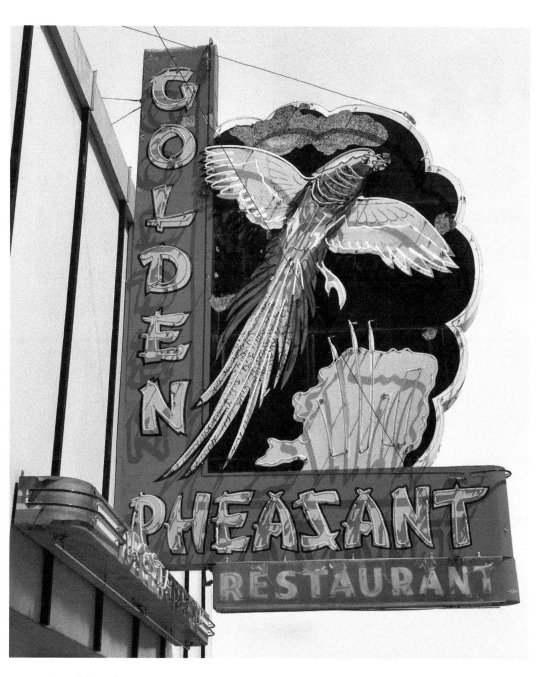

The Golden Pheasant Restaurant in Sunnyside, Washington opened in 1952. In 1973, the restaurant was destroyed by a fire. It was rebuilt in 1974 and this replica of the original sign was installed then. The Golden Pheasant closed in 2010 but the sign remains. It is about 17 feet tall. When it was lit, the sign featured blue, red, orange, green, yellow, and white neon.

The East Wind Drive-in in Cascade Locks, Oregon features a penguin holding an ice cream cone. The restaurant and sign are believed to be from the 1950s. The restaurant went by previous names but it has been the East Wind since around 1982. Although the sign's neon has always been maintained, the paint was peeling badly by the early 2000s. In 2009, the new owner had the sign repainted.

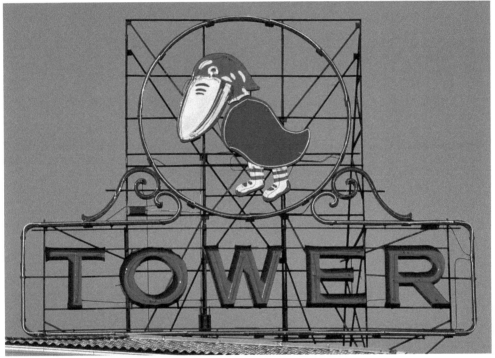

The Hotel Jayhawk in Topeka, Kansas was built in 1926. The original rooftop sign did not feature a jayhawk. It was a simple text sign on rectangular shaped scaffolding. It was most likely a bulb sign. The two, identical neon signs that exist today were installed on the roof by 1935. One faces the south, the other faces east. The signs are 35 feet tall. The hotel closed in the mid-1970s. In 1982, the building was renamed the Jayhawk Tower and converted into office space. At that point, the signs' letters were changed from 'Hotel' to 'Tower'. The signs were restored in 1999. They were repainted again in 2010. A Jayhawk is a mythical bird, which is part blue jay and part sparrow hawk. The bird has been associated with Kansas since the 1850s and became the mascot for Kansas University's football team in 1890. The bird was first depicted in a KU newspaper in 1912. The Jayhawk logo has changed many times over the years. The version which appears on the Jayhawk Tower signs was used from 1923 to 1929.

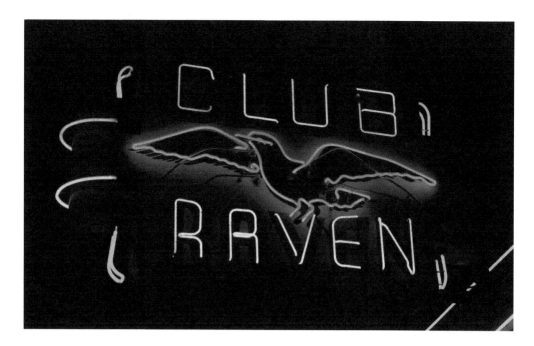

The Club Raven in Sacramento, California opened in 1946. This sign is said to have been built then. It is believed that the sign was poorly constructed since metal was still very scarce immediately after the Second World War. By the late 1980s, the neon was still operating but the panels were falling apart. A replica was built at that time by Pacific Neon for about $2,500. Steel panels, a new flasher, three transformers, and neon tubing were used to create an exact match. It is believed that the original sign was destroyed. The raven's wings are lit in two-part animation to give the appearance of movement. The sign is about 5 feet wide.

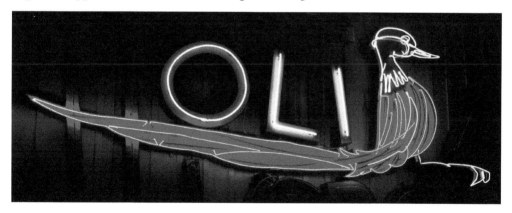

The Holiday Lodge in Lander, Wyoming opened in 1961 and this sign was built then. It is installed on the side of the motel office and is about 15 feet wide. When this photo was taken, some of the neon letters were not working. The pheasant's body is used to create the letter 'D'. His tail creates the horizontal stroke for the 'H'. A fish curls up to make the letter 'O' in 'Lodge' below (not shown).

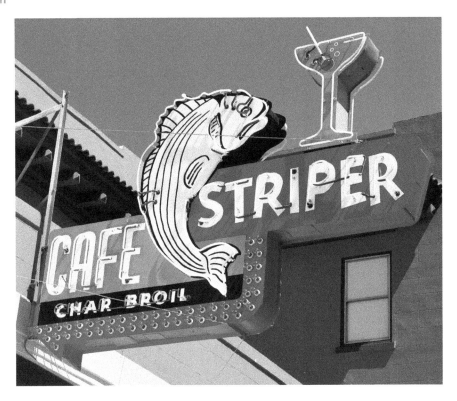

The Striper Cafe in Rio Vista, California opened in the 1930s or 1940s. This sign is most likely from the 1950s. In 2015, an anonymous donor came forward to help the owners with the restoration costs for this sign. The Striper Cafe no longer serves alcohol but the martini glass was left intact.

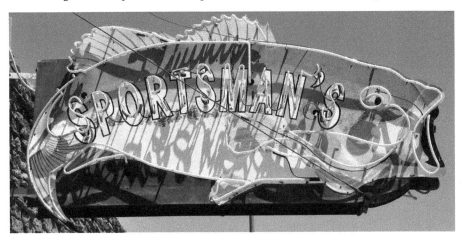

The Sportsman's Club in Overton, Nevada opened in 1955. This sign was installed then. It is about 8 feet wide. The trout was never animated but it has been lit continuously since it was built. The fish is lit with green neon while the text is yellow.

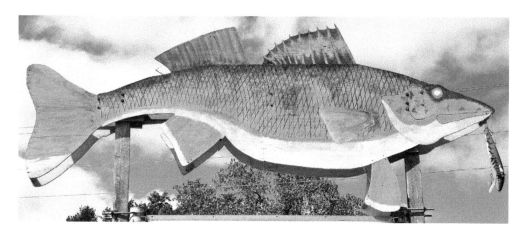

Murray's Outdoor Store in Guttenberg, Iowa is primarily a bait and tackle store. Around 1998, the owner saw the sign at a recently closed taxidermy shop in Mount Carroll, Illinois. She bought the sign for about $200. The giant walleye is made of plywood and is about 16 feet long.

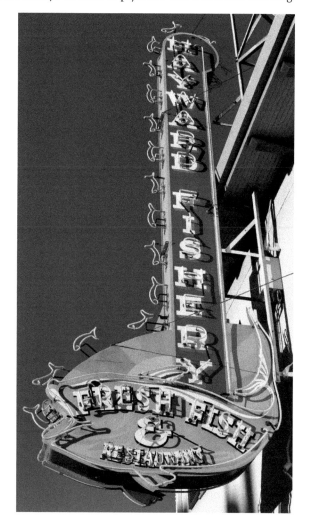

The Hayward Fishery in Hayward, California opened in 1942 and this sign was installed then. It was designed by the business owner, Gus Aguiar, and built for $1,500. The sign was sequentially animated with the small fish descending into the mouth of the big fish at the bottom. Initially, the business was a grocery store, fish market, and bait shop. It didn't become a restaurant until the late 1970s.

By the late 1960s, the sign was only partially lit. The sign was turned off around 1970 after it caught fire. In 1980, the owners decided to remodel the restaurant and have the sign restored. As is the case with most cities, vintage signs cannot be removed and reinstalled. The Hayward sign was repaired and repainted in place for $3,500. The sign's animation was not permitted. The restaurant closed in 2005. It reopened the same year as Art's Crab Shack. Art's added their own sign and had the Fishery sign restored. Art's closed just a few years later. The building remains vacant and the Fishery sign is dark. When it was lit, it featured yellow, pink, green, and white neon.

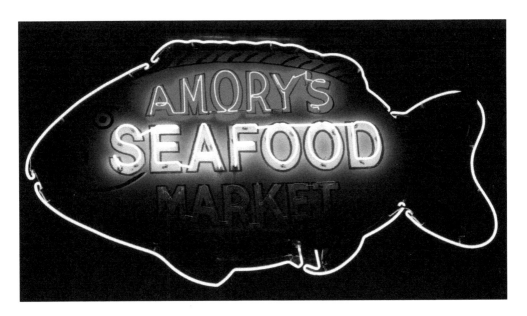

The Amory's Seafood Market sign is located in Hampton, Virginia. It was installed on the roof at another location in town in the 1950s. It was moved to its current location, which is primarily a wholesale business, in the late 1960s or early 1970s. The sign is installed on a pole just a few feet from the Hampton River. The smiling, generic fish is about 8 feet long. The sign was restored around 1980 and it is repaired when the tubing fails.

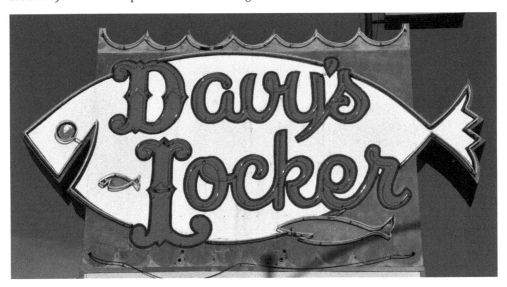

Davy's Locker opened in Las Vegas, Nevada in 1968. This sign was installed then. It was restored in 2011. The fish is nicknamed 'Davy'. The panels were lit with red, green, and blue neon. After fundraising by the bar's management and staff and with a generous offer by Patrick's Signs, the sign was restored again in 2014. In 2016, the bar was sold and the place closed. The new owner scrapped the sign in 2017. The panels were rescued by another bar owner in town. He plans to have the sign put back together and display it inside his bar, the Nevada Taste Site, which will open in 2018. The sign will be altered with beer taps coming out of the panels. The neon will be restored.

The Dog n Suds chain was established around 1954. By the mid-1970s, there were 600 locations in thirty-eight states and Canada. The company went bankrupt in the 1990s. Today, there are only about thirteen locations operating independently. The earliest locations had signs with a more Pluto-like dog. The Walt Disney Company objected and Dog n Suds redesigned its signs. This sign was built for the Lafayette, Indiana location that opened in 1956. These signs feature chasing bulbs. Several of these signs have been repurposed for other businesses. They are easy to identify because of their unique shape.

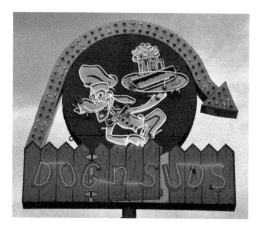

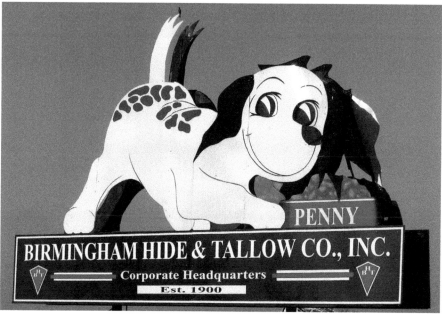

The Penny Dog Food sign in Birmingham, Alabama was installed around 1953. The sign is about 25 feet long. Originally, Penny's tail wagged, her tongue lapped at the food in her bowl, and her eyes moved back and forth. The sign never had neon but it was lit with spotlights. The sign was turned off in 1997 when it was feared that internal wiring might start an electrical fire. Penny Dog Food was the economy brand of the Gold Seal Dog Food Company, which occupied the building beneath the sign. After Gold Seal folded in the 1980s, Birmingham Hide & Tallow Co. moved into the building. In 2005, the sign was repainted and the dog's movement was restored. However, the sign's internal mechanisms failed soon thereafter. In 2010, Birmingham Hide & Tallow moved to a new location. In 2013, the sign was donated to Regions Field, a new minor league baseball park in town. Birmingham Hide & Tallow funded the restoration and relocation of the sign. The steel panels were replaced with aluminium replicas. The sign was installed in the ballpark's parking lot later that year. The dog's eyes, tongue, and tail are fully operational again.

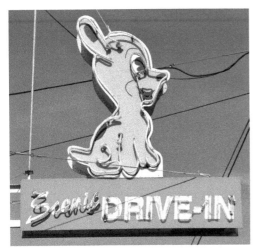 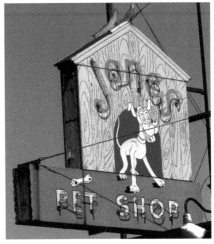

Above left: The Scenic Drive-in in Modesto, California opened in 1956. The owner bought the dog from another business and added it to the sign in 1963. The dog is outlined with white neon. His eyes are yellow and his mouth is red. 'Scenic' is lit in green while 'Drive-in' is lit with red neon.

Above right: The Jones Pet Shop in Nashville, Tennessee opened around 1946. The sign was installed by 1959. The store closed in 1996. Later that year, the Fido coffee shop moved into the space and has been maintaining and lighting the sign. In addition to the Pluto-like dog, there are parakeets on top of the dog house. The sign is lit with red neon.

Below: Leon's Frozen Custard in Milwaukee, Wisconsin opened in 1942. The company had four other locations in Wisconsin but this is the only one left. There are several neon signs at this walk-up stand. This running dog sign was built in 1955 by Royal Neon. It is about 6 feet long. The dog and wieners are outlined with red neon while the grass is lit with green neon. According to the sign shop that maintains Leon's signs, the dog sign would be the most difficult one to replace because of the intricate neon bends.

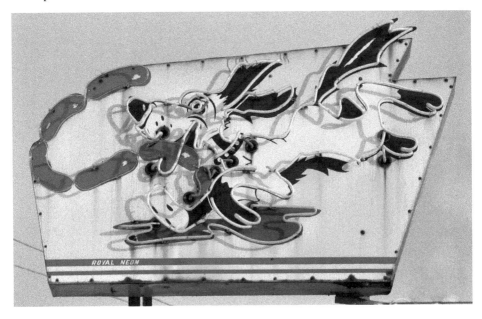

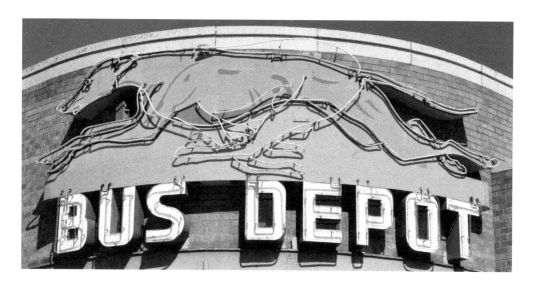

The Greyhound bus station in Pocatello, Idaho was built in 1946 and this sign was installed then. The sign may have been unique. If there were others, they are all gone now. The panels are curved to fit on the Streamline Moderne building's rounded corner. This sign was restored by the city in 1996. In 2015, the neon was restored again with funds from the Relight the Night organisation in Pocatello. The dogs' legs move in two-part animation. Greyhound has not occupied the building since 2004. After that, the building housed Pocatello Regional Transit. The building is currently vacant but there are plans to use it as a transportation museum.

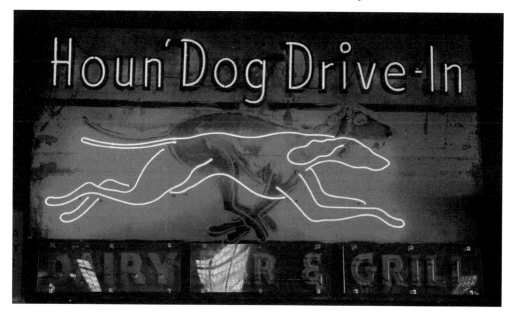

The animated Houn' Dog Drive-in sign is displayed inside Fitz's restaurant in St Louis, Missouri. It was originally installed on the roof of the drive-in in Marble Hill, Missouri in the mid or late 1950s. The drive-in was sold in the early 1980s and the sign was removed at that point. One of the partners at Fitz's found the sign in the basement of a building in St Louis. He bought the sign and had the neon restored. It was installed at Fitz's just before the restaurant opened in 1993. The dog is lit in two-part animation. The sign is about 6 feet long.

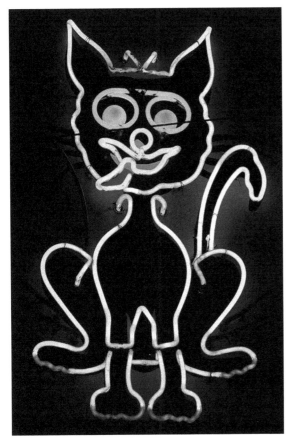

Left: The Alley Cat cocktail lounge opened in Bakersfield, California in 1941. The bar is located in an alley. Sometime after 1955, the business became Oscar's Alley Cat. In 1971, it was renamed Guthrie's Alley Cat. This 3-foot-tall black cat is part of a larger sign, which is probably from the 1950s. It was definitely there by 1962. The cat's tail moves in circular, four-part animation. The cat's eyes are lit with yellow bulbs. The green neon surrounding them flashes on and off.

Below: The Alley bar in Oakland, California opened in 1934, just as prohibition ended. The sign's ripple tin panels probably indicate that this sign is pre-1950s. It might have been installed in 1944 when the bar's interior was redone. The letters are lit with turquoise-green neon. The sign is about 7 feet long.

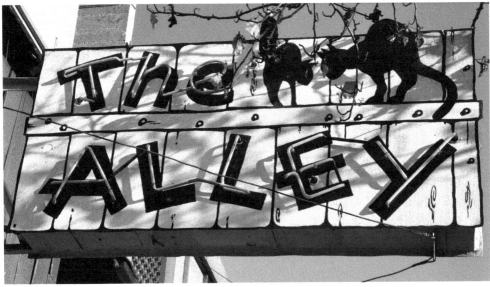

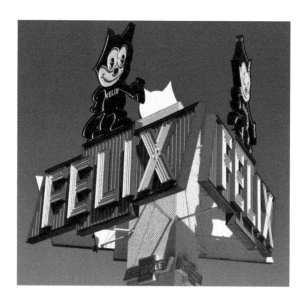

Felix Chevrolet was established in Los Angeles, California in 1922. The business owner, Winslow Felix, was a good friend of Pat Sullivan, the cartoonist who created Felix the Cat. With Sullivan's permission, the dealership has used the character as its mascot since the 1920s. Felix Chevrolet moved to its current location in 1958. This three-sided, rooftop sign, which towers above the showroom, was built then. Felix is outlined with white while his eyes glow green. The Chevrolet logo is outlined with blue while the text is red. In 2012, the sign's neon was replaced with LED (light-emitting diode) tubing. This was done as a cost-savings measure since LED is not only cheaper but promoted as longer lasting. Preservationists were outraged that the change was made despite the sign's landmark status. LED does not have the same warmth and glow as neon. In addition, keeping the sign fully lit has also proven to be problematic.

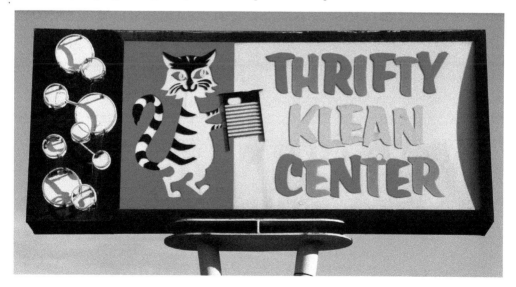

The Thrifty Klean Center laundromat sign in Stockton, California was installed in 1963. It was built by Electrical Products for $500. The sign is installed on a pole and is about 5 feet wide. It features neon soap bubbles and hand-cut plastic pieces affixed to backlit plastic panels. However, the sign has not been lit in many years.

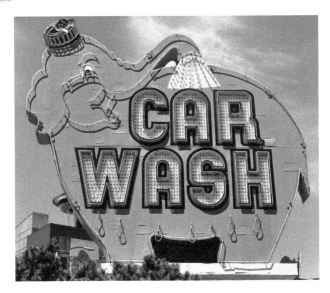

The Elephant Car Wash chain was founded in Seattle, Washington in 1951. This revolving sign in Seattle was built in 1956. It is the biggest and most elaborate sign left. It measures 18 feet by 23 feet. The two sides of the sign are different. One side has animated neon. This side has neon and flashing bulbs.

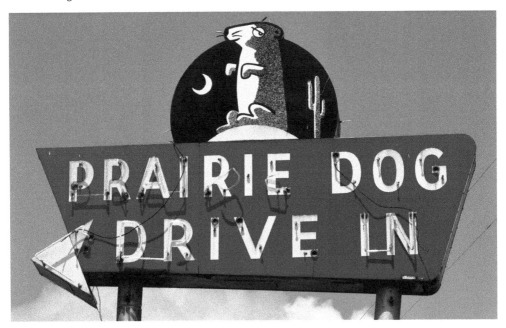

The Prairie Dog Drive In in Grand Prairie, Texas has been open since at least 1957. This sign appears to be from the 1950s. It was built by the Zimmerman Sign Company. The neon has been broken for many years. The panels are about 6 feet wide.

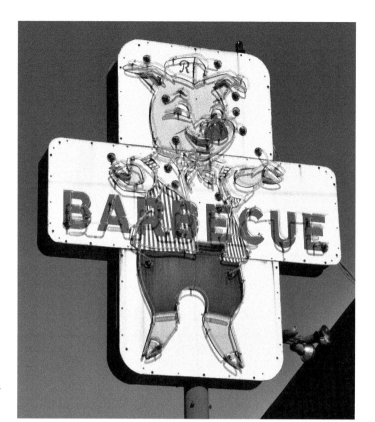

Rudy's Barbeque in Shawneetown, Illinois started out as a sandwich shop in 1932. This sign is probably from the 1950s. It is about 5 feet tall. The restaurant closed in 2016. It is not known if it will reopen or what will become of the sign. When it was working, the sign was lit with red neon.

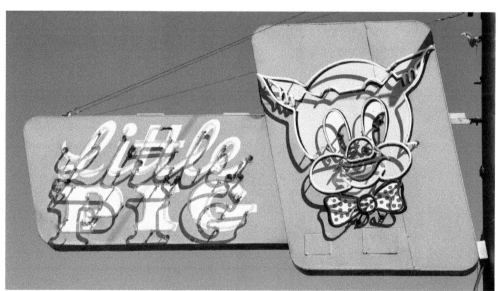

The Little Pig in Baker City, Oregon opened around 1952. This sign is probably from then. The restaurant closed in the 1980s. For a while, the building was used as office space. It reopened as the Little Pig in 2004 and the sign was taken out of storage and reinstalled. The panels were previously painted red. The text is lit with pink neon. The pig is composed of pink, red, orange, and white neon. The sign is about 7 feet long.

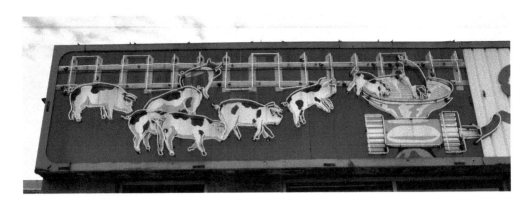

The Rosario's Italian Sausage sign in Chicago, Illinois was designed by the store's owner, Rosario 'Roy' Repole. It was installed in 1968. The sign features a gruesome yet cute depiction of pigs hopping into a meat grinder. Sausage comes out of the grinder and continues into link-like lettering on the plastic portion of the sign. The nine neon pigs and the grinder are lit in a multiple sequence pattern. The neon had been inoperable since at least the 1990s. In 2009, the sign was fully restored. In 2016, the business closed. The sign will be saved but the owner has not decided where it will go. She wants the sign to be displayed where people can see it. The sign spans the full width of the building. The neon panel is about 10 feet wide.

Gaiser's European Style Provisions in Union, New Jersey opened around 1953. This sign is most likely from then. The panel sign below originally read 'Gaiser's Pork Store, Home Made Bologna'. Around the 1990s, the text panels were painted over and backlit plastic letters were installed diagonally across the faces reading simply 'GAISER'S.' The neon pig on top of the sign remains although it is no longer lit. The pig panels are about 5 feet wide.

This yellow bear character was developed in the 1920s by the Bear Manufacturing Company. He appeared on signs at auto repair shops all over the country to indicate that the mechanics were trained by Bear and used Bear wheel alignment tools. The character is sometimes referred to as the laughing bear, the happy bear, or the dancing bear. The Grateful Dead rock band used the character as its mascot without permission or protest from Bear. There are more of these signs left in Southern California than anywhere else. In the late 1940s, several giant, 20-foot-tall neon versions of the mascot were built in the Los Angeles area. The most intact example is this one located in Garden Grove. This sign was built around 1946. It was repainted in 2014. The owner wanted to keep the sign as original as possible and kept the text for 'Truing', even though that practice is illegal now. Although most of the neon tubing is still there, the sign has been dark since about the 1970s. When it was lit, the bear was outlined with yellow and the text on the sign he held was red. The bear's red neon mouth opened and closed. I've been told that the bear's paw closest to the street waved to traffic. However, I haven't seen tubing or photos to support that. The owner can't afford to fix the neon but he hopes to get financial assistance from the city someday.

Things

Donuts

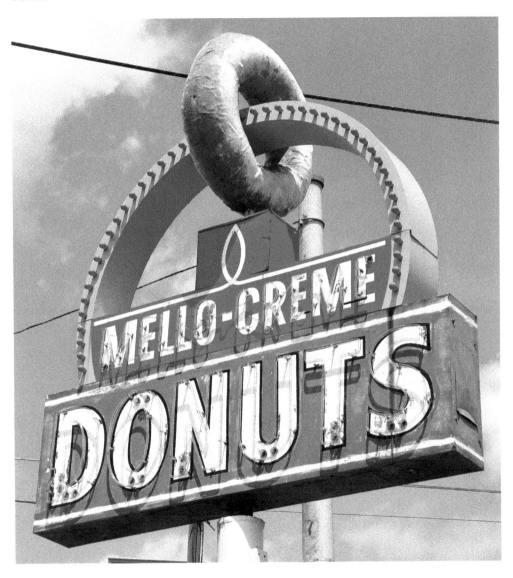

This sign in Lima, Ohio was built in 1970 for Hinkle Donuts. There is another sign like this in Russells Point, Ohio that was built at the same time. The two signs revolved on their poles originally. The giant fiberglass doughnuts were created by using a truck tire inner tube as the mould. When Hinkle Donuts folded in 1973, these signs were acquired and reworked for Mello Creme Donuts. Mello Creme had eight locations at one time but the one in Lima is the only one left. The neon and chasing bulbs operate in the early morning. There is also a neon panel sign on the building, which features a pointing baker and doughnut. The lettering on the Russells Point sign has been changed from 'Mello-Creme' to 'The Donut Shop.'

Dawn Donuts was established in 1920 in Jackson, Michigan. In the late 1950s and early 1960s, pointy-roofed Dawn Donuts buildings were constructed in Michigan and Ohio. Ten of them have survived and now house other businesses. These buildings were accompanied by 'Baker Boy' signs. The mid-century modern building at this Flint location was demolished in 2013. The new building houses the doughnut shop and a Subway restaurant. This Baker Boy sign remains and is the only one left on public display. There are a few others in private collections. The neon on the Flint sign has been missing for many years but the panels still shine. Porcelain enamel panels were commonly used from the 1930s to the 1950s. They were created by baking a coloured glass powder over steel panels. This resulted in a shiny, weather-resistant surface that did not require repainting. If the panels are chipped and not touched up with paint, water can penetrate the surface and rusty streaks can result.

This doughnut-shaped sign was built in 1959 for Norman's Donuts. When the owner retired in 1978, he sold the shop to one of his employees. The business was renamed M&T Donuts, representing the new owners, Mattie and Thomas Roberts. The new name was painted onto the sign at that point. The sign is about 10 feet tall. The sign has been dark for many years. The bulbs in the chevron most likely flashed originally. The very top of the chevron has been bent over since around 2011.

The first Shipley Do-Nuts store opened in Houston, Texas in the 1940s. There are now more than 250 stores in the South and South-West. About half of these locations are in the Houston area. The Shipley Do-Nuts on Ella Boulevard in Houston opened in 1963. It is the oldest location left. This pole sign was built then. There are two other doughnut-shaped signs on the roof that are outlined with neon. All of the other Shipley stores have plastic signs.

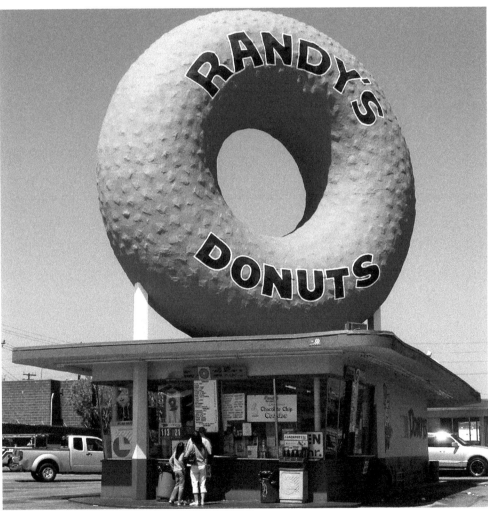

Randy's Donuts in Inglewood, California opened in 1953. It was the second location built for the Big Do-Nut Drive-in chain. The first store opened in Los Angeles in 1950. There were about ten locations built in the Los Angeles area. All of them had these 32-foot-tall doughnuts installed on their roofs. Five of these buildings with giant doughnuts still exist and operate with different names.

The McDonald's hamburger chain was established in 1940. The Speedee running chef character was developed in 1948 as the mascot for the company's 'Speedee Service System.' The character began appearing in signs by the early 1950s. The McDonald's on Shawano Avenue in Green Bay, Wisconsin was built in 1959. This sign was installed then. While the building has been replaced twice, the sign has survived. It was restored in 2005 and has been repainted at least once since then. The neon is lit at night but the Speedee figure has not been animated for decades. The maintenance is paid for by the local franchise. Once commonplace, the only other sign like this at an operating McDonald's is in Muncie, Indiana. There are three others on display at museums.

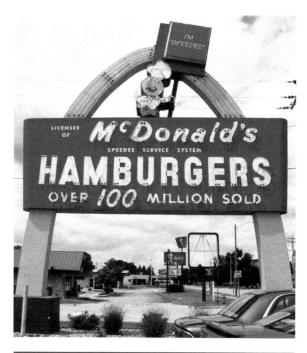

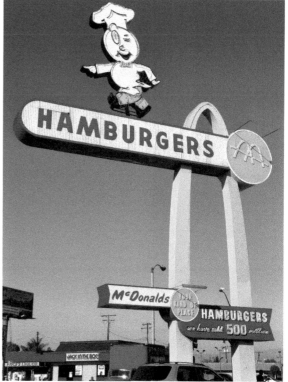

The McDonald's on Lakewood Boulevard in Downey, California was built in 1953. It is the oldest still operating location in the chain. The glass-fronted, walk-up building features the original parabolic Golden Arches design and red and white striped tile. In 1959, this 60-foot-tall neon Speedee sign was erected at the site. It was the only sign built with this design. The neon is well-maintained. Speedee's arm swings back and forth and his feet move in a running motion.

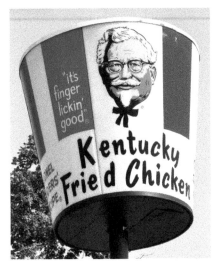

The Kentucky Fried Chicken paper bucket was invented in 1957. In 1961, the company's first plastic bucket sign was created. By the 1970s, these signs were everywhere. They originally revolved. When the company changed its name to KFC in 1991, most of these signs were replaced with modern rectangular signs. In recent years, KFC has brought back bucket signs but the Colonel's face is stylized and has no detail. The 'finger lickin' good' slogan is no longer used. There are only two vintage bucket signs left at operating locations. The sign shown here is in Grinnell, Iowa and the other is in San Jose, California. The Grinnell location opened in 1968 and the sign was installed then. The owner must keep the sign clean and fully lit to satisfy corporate owners, who would rather see the sign removed.

Left: This Taco Bell sign was installed in Savannah, Georgia when this location opened in 1979. It is the only sign like this still on public display. It may have survived in part because this sign is by the back entrance. The sign in front of the restaurant is modern.

The first Taco Bell opened in Downey, California in 1962. The earliest, vacuum-formed plastic signs featured a sleeping Mexican under the sombrero. The man's serape had bulbs along the stripe. By the 1970s, the politically incorrect image had been painted over or replaced with a plastic piece like the one on the Savannah sign. PepsiCo bought Taco Bell in 1978. In 1982, the company decided to change the buildings and signs. These signs were replaced at that time with bell signs.

Below left: There were about 200 Ku-Ku drive-in locations in the Midwest by the mid-1960s. Ku-Ku referred to the restaurants' cuckoo clock theme. By 1969, the chain had folded. In 1973, Eugene Waylan bought the location in Miami, Oklahoma and renamed it Waylan's Ku-Ku. It is the only operating location left. The building and sign are from 1965. The birdhouse on top of the sign advertised the burger price of '15¢'. Later, that was changed to '19¢' until the panel became blank as prices went up. Waylan added his name to the sign around 1977 when the ice cream cone was also added. Sometime after that, the original red panels were painted green. The sign has always been maintained. The plastic cuckoo is backlit while the rest of the sign is lit with red, pink, and green neon.

The first Frostop Root Beer stand opened in Springfield, Ohio in 1926. By the 1960s, there were over 350 locations in the South and Midwest. The chain folded in the early 1980s. However, several stands still operate independently. It is believed that the first revolving Frostop mug sign was built in 1954 and installed in Jefferson, Louisiana. The sheet metal mugs are about 14 feet tall. There are about a dozen of these signs still on display. The original mugs did not have neon. The only one that does have neon is the one shown here in LaPlace, Louisiana. This location opened in 1958. The neon was added to the mug in the 1960s when it was moved from the roof to a pole. It was restored in 1987. In 2007, the mug was completely rebuilt for about $20,000.

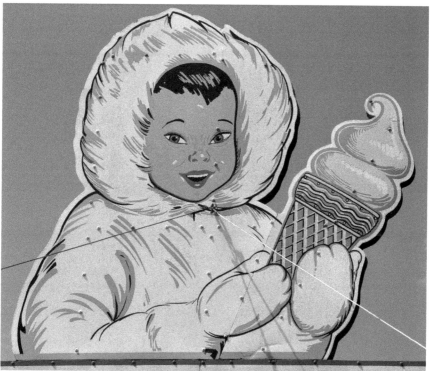

The Dairy Queen in Grafton, West Virginia was built in 1957. This Eskimo sign is from then. There are only two others like it left in the country. One, which had been crudely repainted, has been in storage at the Cape Fear Museum in Wilmington, North Carolina since 1998. The other is a well-maintained sign at the Dairy Freeze in Quincy, Massachusetts. Another Eskimo sign at a Dairy Queen in Charlotte, North Carolina was rebuilt and has a very different paint job. These signs never had neon. In 2016, the Grafton sign was temporarily removed and painstakingly repainted. It is about 6 feet tall and lit with spotlights. Dairy Queen's corporate executives would prefer that the sign be taken down since it does not fit with current branding. However, the owner of the Grafton location is holding firm to keep the sign.

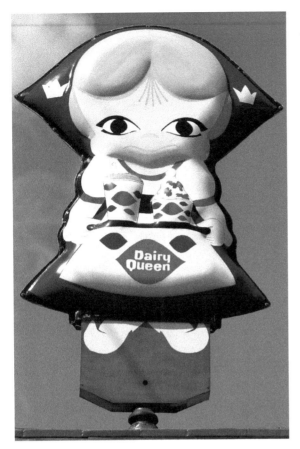

This Little Miss sign is located at the Dairy Queen in Hibbing, Minnesota. The flat-roofed, walk-up stand was built in 1948. The building was remodelled around 1973 into a barn-style building. These Little Miss signs were first produced in 1961 and there are only seven others at operating locations. The signs are 5 feet tall and were installed on the cupolas of Dairy Queen's barn buildings. These signs were internally lit and revolved. They also had weathervane-like features. Four metal arms projected from the signs' bases, each capped with different coloured, plastic Dairy Queen logos. While DQ called it the 'Ellipse', most people refer to the logo as the 'kiss' or 'lips'. The only intact weathervane is at an Atlanta, Georgia location. The Dairy Queen in Hibbing also has the 1970s plastic milkshake and ice cream cup signs on the front of the building. The corporate management of Dairy Queen would like to see them replaced with a modern logo sign but the owner is fighting to keep the vintage signs.

This strawberry sundae sign is located at the 13th Street Dairy Queen in Terre Haute, Indiana. This one-of-a-kind sign was built by the Paulding Sign Company in 1957. The neon sundae is about 6 feet tall. It is superimposed over a flashing, bulb-studded chevron which is about 15 feet wide. The only other neon Dairy Queen sign depicting an ice cream sundae cup is in Huntington, Indiana.

This sign is located at the Carvel ice cream stand in Hackensack, New Jersey. Usually, these revolving 4-foot-tall plastic cone signs were installed on the front corners of Carvel's slant-roofed walk-up stands. The neon text was installed on the sides of the buildings. In this case, when this store was built in 1969, the company was transitioning to strip mall locations. This sign might have been the only one built this way. By 1974, the cones had stopped revolving. The motors were burned out and deemed too expensive to replace. However, the cones are still internally lit and the neon letters still flash on and off. Since the flashing action has always been maintained, it is grandfathered by the city. Most cities prohibit flashing and animated signs. The Carvel neon is repaired twice a year. The owner considers it very important advertising. The diamond-shaped reflectors were replaced

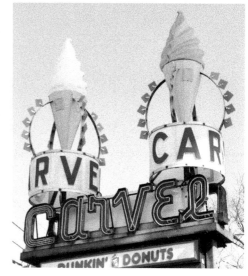

in 1990. Some vintage Carvel signs had balls instead of diamonds. Some of them have different wording on the plastic rings beneath the cones. They read '36 Flavors' and 'Ice Cream'. There are only six other intact plastic Carvel ice cream cones like this left. They are all located in New York. There are two others at a Carvel in West Palm Beach, Florida but the style of those is different.

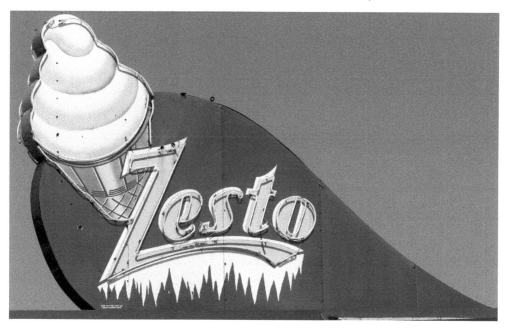

The Zesto frozen custard drive-in chain was established in 1945. The Zesto Drive Inn in Watertown, South Dakota was built in 1953. The business and this rooftop sign were moved to the current location in 1965. The sign is about 15 feet long and was built by the Bob Smythe Sign Co. of Cedar Rapids, Iowa. The ice cream is outlined with white and yellow neon. The Zesto text is lit in red. Originally, the curved panels were outlined with blue. That tubing is missing now. There are about twelve other signs like this but only five still have neon.

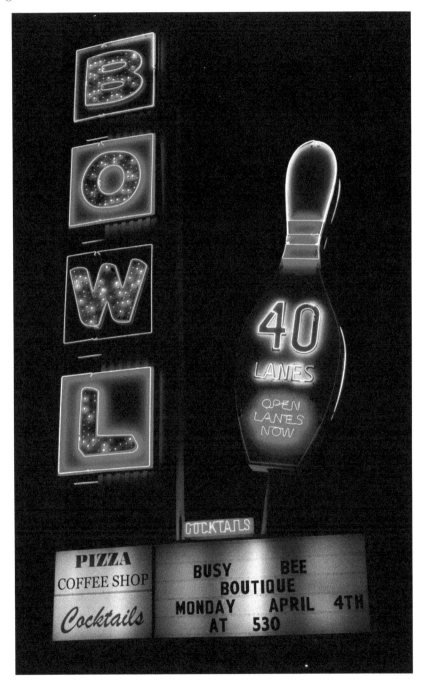

The Linbrook Bowl in Anaheim, California opened in 1958. This sign is believed to be from then. It is about 25 feet tall and features a revolving bowling pin. The 'BOWL' letters are lit with scintillating, flashing bulbs.

The Triangle Bowl in Longview, Washington opened in 1957. This sign is believed to be from then. It was built by the Vancouver Sign Company and has been restored twice. In 2006, the panels were repainted and the neon was replaced. The 'BOWL' text and the bowler flash on and off in sequence. The bowling alley is located in the Triangle Mall which occupies a triangular-shaped lot. The sign is about 15 feet tall and has triangular-shaped panels. There are plans to redevelop the mall within the next five to ten years. The bowling alley will have to move. The new location and the fate of the sign are unknown at this point.

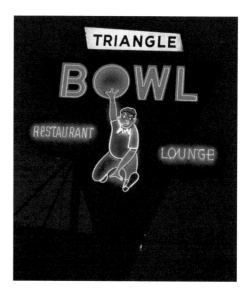

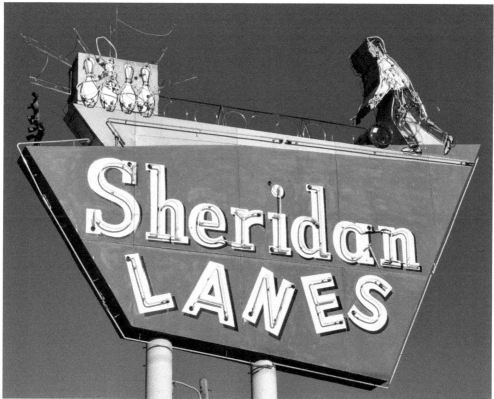

The Sheridan Lanes sign in Tulsa, Oklahoma was built in 1957 by Claude Neon. In 1998, the bowling alley was purchased by the AMF chain and the sign was taken down and replaced. After pressure from the community, the neon sign was reinstalled around the corner. The neon and animation are still maintained. The sign is lit with pink, green, yellow, red, orange, white, and blue tubing. The bowler's arm moves back and forth, the ball rolls and the pins explode. The panels are about 10 feet wide.

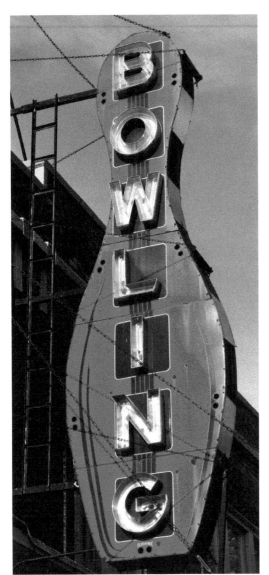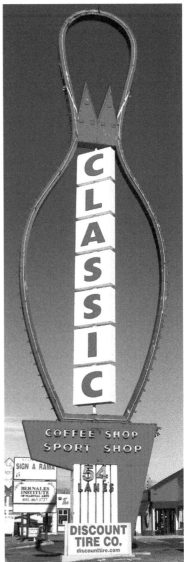

Above left: The Fireside Bowl in Chicago, Illinois opened in 1941. This sign was built by Flashtric. It was installed in the early 1950s or when an addition was made to the building in 1956. The channel letters were added to the panels around 2003. The metal protects the neon tubing from vandals and weather. The letters are lit with red neon. There was originally neon around the bowling pin's border. The pin is about 22 feet tall. Chicago charges fees for signs that project over the sidewalk. The Fireside Bowl pays $600 a year for this sign. In addition, the owner spends between $500 and $1,000 annually to keep the neon working.

Above right: The Classic Lanes in Salt Lake City, Utah opened in 1958. This 90-foot-tall sign was built then. The revolving, backlit plastic panels read 'CLASSIC' on one side and 'BOWLING' on the other. The giant pin was outlined with red neon. The text below had red and blue neon. In 2015, the bowling alley closed and was demolished. Just before this book was published, the sign was replicated for the Ritz Classic Apartments by YESCO, which built the sign originally. The wording at the bottom now reads 'Apartment Homes'. LED was used instead of neon.

The Gold Crown Lanes in Fort Morgan, Colorado was built in 1961. This sign was installed then. In 2014, the bowling alley reopened as the Morgan Lanes. The new owner looked into having the sign repainted and the neon repaired. The estimate was $23,000. He passed. There are no plans to remove the sign despite offers from collectors and dealers. The text on the bottom of the sign mentions that this facility had a nursery, which was a common perk at bowling alleys in the 1950s and 1960s. Parents could drop off the kids and head off to the bar or lanes. This nursery has been used for storage since about the 1970s.

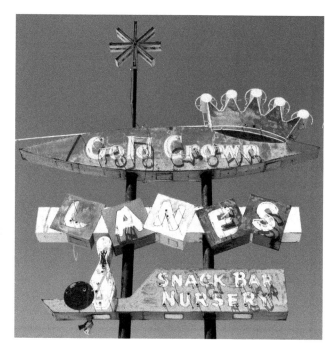

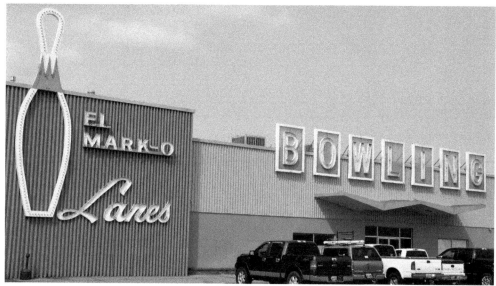

The El Mark-O Lanes in Casper, Wyoming opened in 1960 and these signs are from then. The name came from combining the owners' names, Elma and Mark O'Connell. The giant bowling pin continues to be lit with white chasing bulbs. The name 'El Mark-O Lanes' is lit with pink neon. The 'BOWLING' panels have not been lit for many years. The owner found them too expensive to fix. The building was previously painted two shades of green. Around 1990, the building was repainted to its current colour scheme.

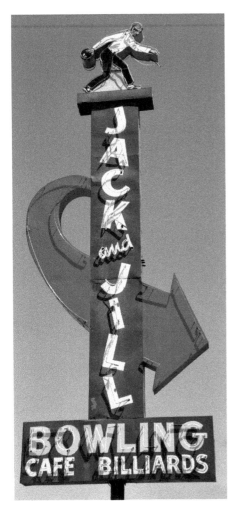

The Jack & Jill Bowling Lanes in American Fork, Utah opened in 1957. This sign was installed then. The bowling alley was named after the owners' two daughters, Jackie and Jill. The sign is about 50 feet tall and is installed on a 14-foot-tall pole. For the first few years, there was additional neon on the arrow that flashed. It was too much trouble to keep it working and that feature was removed. The bowling alley moved in 1984 and the sign was installed at the new place the following year. YESCO, which probably built the sign originally, maintains the neon and repaints the sign every five years. The sign is lit with green, blue, red, orange, and white neon.

The Hawk Bowl in Whitewater, Wisconsin opened around 1958 and this sign appears to be from then. The sign was made by Osgood & Co. of Beloit, Wisconsin. It is about 12 feet tall and is lit with orange, green, pink and orange neon. Another neon sign above the entrance reads '16 Brunswick Lanes, Automatic Scoring'.

The Skate America Fun Center in Texarkana, Texas opened in 1983. This sign may be from then. It is about 5 feet tall and is installed on top of a billboard type sign. In 2016, the skating centre moved to a new location and closed just a few weeks later. It is not known what will happen with this sign.

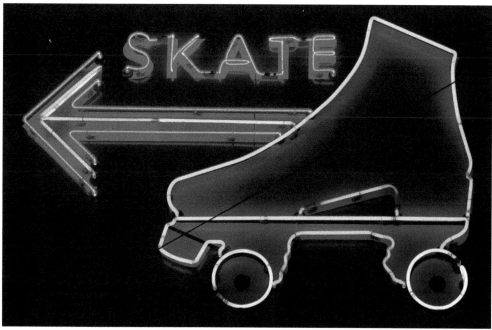

Carousel Skate in Sioux Falls, South Dakota opened in 1974. This sign is believed to be from then. In 2015, the skating rink became part of the Skate City chain. Some of the sign's neon tubing was fixed then. By day, the skate, text, and arrow are white on a purple background. The sign is about 4 feet wide.

The Deleta Ballroom was established in 1941 in Montpelier, Idaho. In 1945, the owner disassembled the building and rebuilt it in Pocatello, Idaho. The name came from combining the owner's names: Del and Leta Holland. The business featured dancing on weekends and skating during the week. It remained a skating rink into the early 1950s. The building later housed a variety of businesses including a bar, a grocery store and an army surplus store. Around 1972, the place became a skating rink once again. This sign is presumed to be from then. The female skater has bell-bottom pants and a flip hair style typical of the time. The business is now known as the Deleta Skating & Family Fun Center. 'Deleta' is lit with red neon.

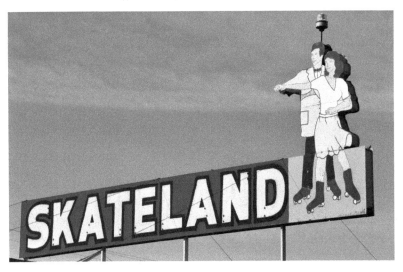

Skateland in Bakersfield, California opened in 1955. This rooftop sign had neon until around 1960. The tubing was removed after it was damaged by vandals. The sign's skaters were modelled after an unidentified couple from a photograph submitted to the sign shop. The sign is about 29 feet long and the skaters are about 11 feet tall. It has been repainted about four times in the original colours. Around 2000, the woman's roller skates were painted as roller blades. When the sign was repainted in 2015, the woman's roller blades were changed back to skates.

The Sandman Motel in Reno, Nevada was built in 1949 as the Travel Lodge. This nearly 40-foot-tall sign was erected then. Some of the painted 'MOTEL' letters still reveal the shapes used when the sign panels read 'LODGE'. That text was changed in 1955 when the business was renamed the Travis Motel. Some say the name change took place because of pressure from TraveLodge, which was an established motel chain by the early 1950s. In 1966, the Travis Motel became the Sandman Motel and the sign's top panel was altered again. The car on the sign has been there since the beginning. At one time, the neon wheels flashed to simulate motion. While the motel is still open, the sign has been dark for many years. It was lit with red, green, blue, and gold neon. The three backlit plastic credit card signs attached to the pole are from the 1960s.

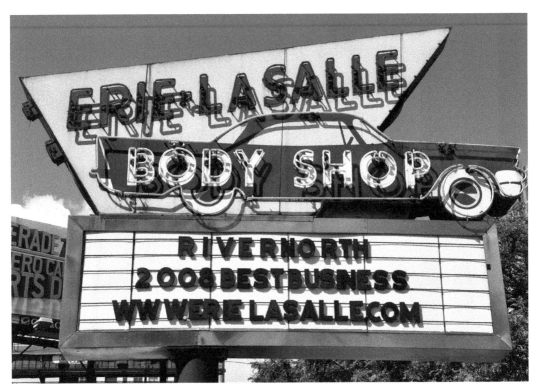

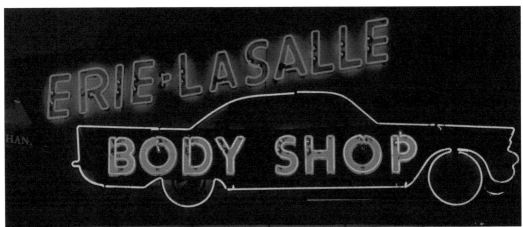

The Erie-LaSalle Body Shop in Chicago, Illinois opened in 1934. The sign was built in 1957 by White Way Sign. It features what was then a current model 'Forward Look' Chrysler. The sign is about 10 feet wide. It was never animated. In 2016, the body shop moved down the street. The sign was removed and restored. New internal components were installed. The rust was removed and the panels were repainted. After deliberating, the owner decided to keep the original, old-fashioned message board rather than upgrading it to a digital equivalent. The sign was installed at the new location in 2017.

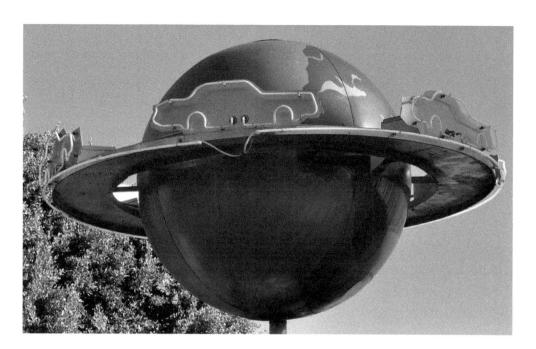

This former Earl Scheib sign is located in Beverly Hills, California. Earl Scheib opened his first auto body and paint shop in Los Angeles in 1937. The company became a nationwide chain. During the 1950s, the company developed this globe sign with revolving neon cars. It's not known how many were produced or if they were used outside of the Los Angeles area. The only other known survivor was installed in Compton, California. It is now at the American Sign Museum in Cincinnati. These globe signs were installed above steel panel signs with text and neon reading 'Earl Scheib Auto Painting'. The globes are about 6½ feet wide. The rings around the globes support six cars outlined in alternating neon colours. The history behind the Beverly Hills sign is a mystery. Some say that there was previously an Earl Scheib shop on the site of the present-day strip mall. It is not known who owns the sign but the neon continues to be lit at night. The metal cars appear to be original but the ring no longer spins. The neon on both the Beverly Hills and Cincinnati cars are simpler replacements. The original neon on the cars included round roofs, front and rear bumpers, and round wheels.

The Clackamas Auto Parts store in Oregon City, Oregon was founded in 1934. The business moved to its current location in 1945. The store's sign was built in 1966. The combination of steel, neon, and plastic was common in the 1960s. The sign is about 11 feet wide. It was restored in 1996 after obtaining a permit from the city for its temporary removal. Most cities do not allow vintage signs to be removed and then put back up which makes repairing them difficult. The Model T is outlined with white neon and has animated, red neon wheels. The sign's neon arrow flashes on and off.

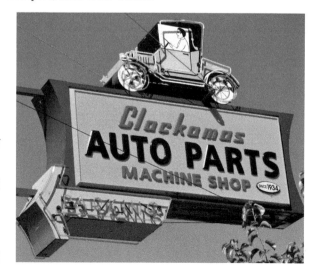

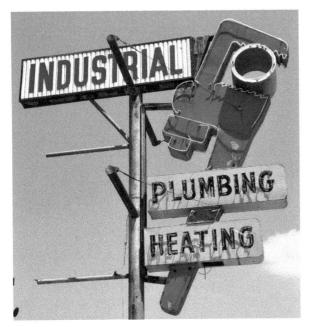

The Industrial Plumbing & Heating sign in Oklahoma City, Oklahoma was built in 1946. The 'Industrial' corrugated plastic panel was apparently added in the late 1950s or early 1960s. There was probably neon text in that spot originally. The sign's neon hasn't worked since at least the 1980s and the company has no plans to restore it.

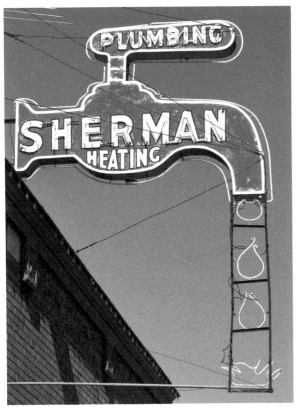

The Sherman Plumbing & Heating Co. sign in Clinton, Missouri was installed in 1947. It was the first animated sign in town. The neon has always been maintained. The sign was repainted in 1994. At night, the sign features red lettering, a green outlined faucet, and blue drips. The three sequential drips are followed by a splash. Vandals have targeted the delicate neon tubing several times, but the sign has always been swiftly repaired.

These two animated neon signs are located at Jack Stephan Plumbing & Heating in Los Angeles, California. Each sign is at least 15 feet tall. One faucet pours water with sequentially lit strands of tubing. The other faucet has five drops that are lit in sequence. Chief Neon produced these signs in 1946 for $1,500. The signs have been dark since around 2015. The owner would like to restore the signs. However, the neon is a frequent target of rock-throwing vandals. With the most recent estimate to repair the signs at $5,000, restoration plans are on hold for now.

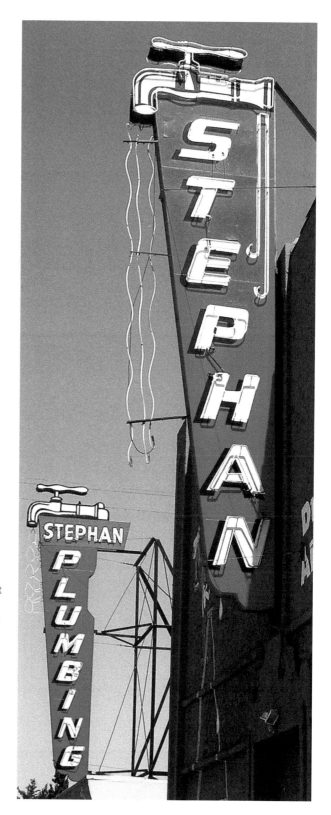

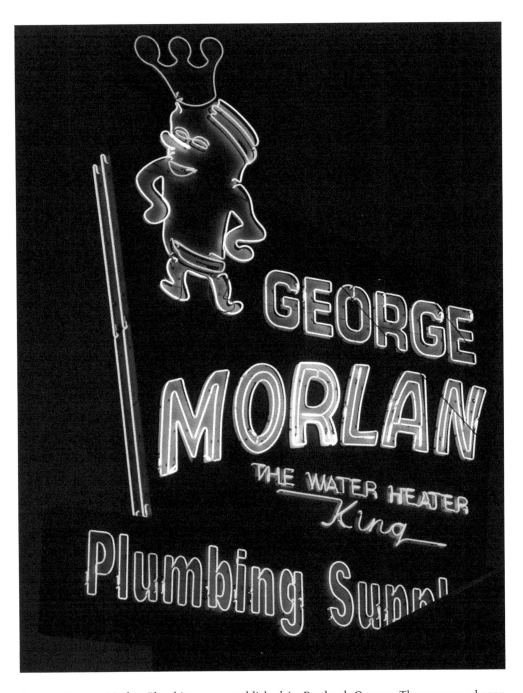

In 1927, George Morlan Plumbing was established in Portland, Oregon. The company began selling its new invention, the electric water heater, around 1935. Morlan sold about 2,500 of these per year and was dubbed, the 'Water Heater King'. In 1946, the company expanded its showroom and installed this sign. It is roughly 16 feet wide and 30 feet tall. The sign has 754 feet of neon tubing. The water heater character is referred to as 'The King'. A costumed, human mascot version of him appears in local parades. The sign's neon had been inoperable for many years when Morlan decided to repair it in 1996. It was completely refurbished by Columbia Neon of Vancouver, Washington for $24,000. The King's animated feet appear to dance at night.

Preserving Vintage Signs

It would be nice to see vintage signs stay in place at their original locations forever. However, since most of these signs are metal and well over fifty years old, rusting panels and supports can make them public safety hazards. Some signs have crumbled to bits when experienced sign shops have gingerly tried to remove them for restoration or relocation.

In addition, most cities have laws that prohibit vintage signs from being removed and reinstalled. These grandfathered signs can only be repaired or repainted while they are in place. That makes a thorough restoration nearly impossible. In some cases, city variances can be obtained that permit the sign's owner to have the work done off-site. However, most small business owners have neither the money for a full restoration nor the interest in dealing with city bureaucracy. It's much cheaper and easier to replace the sign with a modern backlit plastic box.

Some vintage signs have been locally landmarked to keep them in place. On the surface, that sounds like a good idea. When a new business moves in, that usually means only a small part of the sign can be adapted for a name change. However, often it means the sign can be changed significantly: the neon removed, the panel repainted with modern fonts, or modern backlit plastic letters glued onto the panels. The result is a sign that looks like the original in shape only. Once this happens, it's very rare that the sign is restored back to the original appearance later. With drastic alterations, it can be argued that the sign would have been better off going to a local museum or a private collector.

Most of the time, what happens to signs is determined by their owners. The owners recognize that neglected signs are not good for business. However, restoring a neon sign can cost $10,000 and upwards, depending on the size and condition of the sign. The business owners often opt to remove the neon and repaint the sign themselves. The historic patina and details of the sign panels are lost in order to create a fresh and clean look.

Very often, the owner decides to sell the sign to a collector or scrap it for an affordable replacement. In some cases, the sign gets donated to a local museum or historical organisation where it is either displayed or put in storage. Museums have limited space and will usually only take small or significant signs.

Removing large neon signs is expensive. This may be a blessing since it may postpone their removal. However, this cost might also keep an interested museum or collector from saving a sign. Many times, these signs wind up in the scrapyard when a building is remodelled or demolished. Sometimes, an owner believes that the sign is worth more than it is and holds out for a 'serious buyer' until demo day. Again, the sign winds up being destroyed.

However, it's not all gloom and doom. With the increasing recognition of these signs as historic landmarks, many signs have been restored with financial assistance from city agencies, historic organisations, and community fundraising efforts. With the immediacy and reach of social media, many signs have found homes or been restored with online fundraising.

If the original steel panels are in decent shape, the sign's historic patina can be preserved. The internal components can be replaced, the panels can be touched up to

prevent rust, and the neon can be reproduced. However, with a truly dilapidated sign, the rational decision is to create a replica. Ideally, the original sign can be displayed inside the business or donated to a local museum or collector. Not all replicas are created equal but, if it's done well, it ensures that the sign might survive another fifty-plus years. The new steel panels are usually replaced with rust-proof aluminium while the paint and neon colours are matched to the original.

During restoration, many neon signs are now being converted to LED lighting. While LED tubing is more energy efficient and might be cheaper to maintain, it does not have the same warmth and glow as neon. Another unfortunate trend during sign restoration is the replacement of original message boards with changeable letters to moving digital display panels.

Many sign shops are currently amassing small collections of unwanted signs that they are happy to show to the public. Some cities have teamed with museums or collectors in creating sign parks or downtown areas decorated with signs from closed, local businesses. Some examples are the Old Town sign park in Saginaw, Michigan; the Victoria Gardens shopping centre in Rancho Cucamonga, California; the Pomeroy City Walk in Pomeroy, Washington; the Neon Sign Art Walk in Tucson, Arizona; the Neon Alley in Pueblo, Colorado; and the Neon Sign Museum in Edmonton, Alberta.

A few museums and organisations have local sign collections on permanent display. These include the Yakima Valley Museum in Yakima, Washington; the Kern County Museum in Bakersfield, California; the Big Fresno Fair in Fresno, California; and the Doo Wop Experience in Wildwood, New Jersey.

Some collectors have signs on public display at their businesses. Some examples are the Stokely Event Center in Tulsa, Oklahoma; the Carpet Gallery in Poplar Bluff, Missouri; the Grandma's Saloon & Grill chain in Duluth, Minnesota; Wilson's General Store & Cafe in Evansville, Indiana; and Terry's Turf Club in Cincinnati, Ohio. Many car dealerships also have collections of vintage signs on display inside their showrooms.

In addition to the three main vintage sign museums described here, there are current plans for other sign museums in The Dalles, Oregon; Reno, Nevada; and Oklahoma City, Oklahoma.

American Sign Museum (Cincinnati, Ohio)

The American Sign Museum features a dizzying display of over 300 signs from the late nineteenth century through the early 1970s. The growing collection of signs come from all over the country. Tod Swormstedt opened the museum's first location in 2005. In 2012, the museum was moved to a much larger space of 40,000 square feet. Half of the space is the museum proper and the other half serves as a warehouse for signs not on display. The 28-foot-tall ceilings allow the huge Howard Johnson's and McDonald's Speedee signs to be displayed indoors. The 'Main Street' area with simulated storefronts is a reminder of what downtowns looked like when nearly every business had an electric or neon sign. The building also houses Neonworks, a neon shop that restores local signs and maintains the museum's collection. There is also an event space that can hold up to 400 people.

The museum's signs are only gently restored. Broken neon tubing and bulbs are replaced to make them functional again. Only rarely are the signs repainted. The signs' patina and imperfections are preserved and considered part of their history.

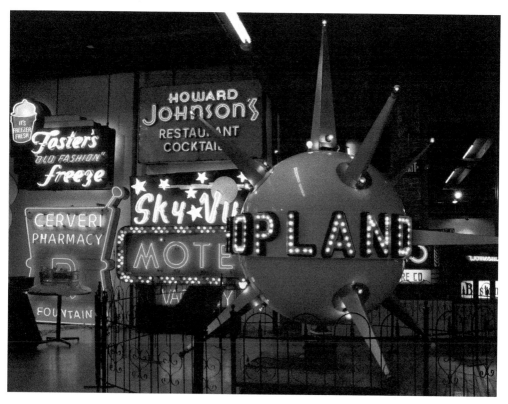

MONA was founded in 1981. After temporary locations in downtown Los Angeles and Universal City, the museum opened at its permanent home in Glendale in 2016. From the beginning, the museum's dual focus has been on showcasing vintage signs and contemporary neon art. MONA has a storage facility in Pomona, California where it has close to a hundred vintage signs. There are plans to restore many of these signs and display them on a rotating basis at the museum in the future. The museum's classroom is used for demonstrations by skilled neon craftspeople and workshops where visitors can learn tube-bending techniques. In addition, MONA continues to offer Neon Cruises. Since the 1990s, hundreds of these night-time, double-decker bus tours have taken place. The focus has been on vintage and modern neon signs in Hollywood, the Wilshire District, Chinatown, and downtown Los Angeles. The megaphone-equipped tour guides provide information and entertainment along the route.

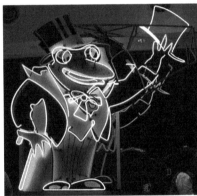

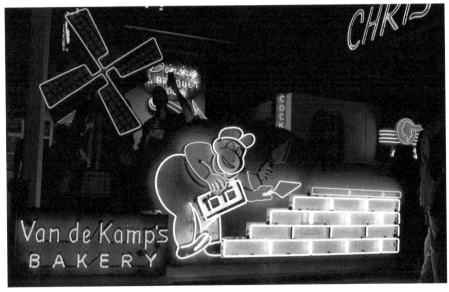

The Neon Museum has been collecting and restoring local neon signs since 1996. The signs are stored just north of downtown at a site dubbed the Neon Boneyard. The museum officially opened in 2012. There are more than 200 signs at the museum with others in storage around town. The collection is open to the public through tours which are available during the day and at night. The signs were saved from Las Vegas motels, hotels, and other businesses which were either remodelled or demolished. Among the signs are those from Caesars Palace, the Golden Nugget, Jerry's Nugget, the Yucca Motel, the Moulin Rouge, and the Stardust. In addition, the museum has restored many signs and installed them at various locations in town. They came from the Hacienda Hotel, Binion's Horseshoe, the Bow & Arrow Motel, the Silver Slipper, the Landmark Hotel, the 5th Street Liquor Store, Society Cleaners, the Lucky Cuss Motel, and the Normandie Motel.

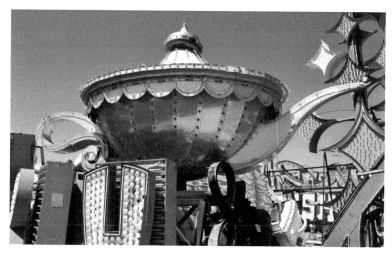

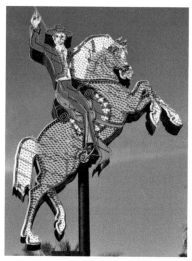

Here are some things that you can do to help save vintage signs:

Share the Love. Let business owners know how much you love their signs. Give them your contact information and develop a friendship with them. Bring them coffee or call them on their birthday. Stay in touch and have them reach out to you if they are considering removing, altering, or restoring their sign. Keep in mind that collectors are doing the same things and making offers to acquire the signs. Tell the owner how important the sign is to the community and tourists and what an asset it is to his or her business.

Find Friends and Be Proactive. Develop a local or regional sign community. Find like-minded people that are interested in documenting and protecting signs. Produce a local guide with facts about each sign and maps for walking or driving tours. These are a great way of providing information for the public, tourists, historical organisations, and city officials. This information might be useful to establish the signs as local landmarks and make them eligible for restoration funding.

Restoring and Fundraising. If the owner is considering restoring the sign, you might want to discuss preserving the sign's patina and historic value. Perhaps you can help with getting estimates from sign shops. Find out what the city's policy is about removing signs for restoration and what's involved in getting permission to remove/reinstall if needed. Are city matching grants available? You might be able to help with fundraising. Many signs have been restored with organized online and media campaigns. Community events such as bake sales, car washes, and concerts should not be underestimated as ways to create public awareness and raise money. With doggedness and luck, donors and sponsors can often be found. TV and print coverage can reach a nationwide internet audience. A well-publicised online fundraising website such as GoFundMe or KickStarter can be an important tool.

Uh-oh, It's Closed! When a business closes or is about to close, try to find out what the plan is for the sign. Is it landmarked? Will the business or building owner be taking it down or auctioning it off? Will the next tenant be allowed or encouraged to adapt the sign? If a sign is at immediate risk of being removed and destroyed, contact local museums, historical organisations, and sign shops. Post the information at Facebook groups (local and sign-focused). Can the sign be stored at a museum, sign shop, or local business until a place is found to display it locally or a home can be found?

By becoming a self-appointed guardian of signs, you may be able to save a few from the scrap heap.